# DALI by DALI

Translated from the French
by Eleanor R. Morse

HARRY N. ABRAMS, INC. PUBLISHERS NEW YORK

Standard Book Number : 8109-0071-8
Library of Congress Catalogue Card Number: 74-161619
Copyright 1970 in France by Draeger, Éditeurs, Paris
Harry N. Abrams, Incorporated, New York
Printed and bound in France

# THE COSMIC DALI

## The "Royal Way" of Access to the Dalinian Universe

*Since 1950 almost all Dali's philosophical reflections and speculations have been concerned with cosmic themes and paths; and* always on a parallel with his work as a painter, *to the point that these parallel paths are a key giving access to the comprehension of his works.*

*But there is another key, the real royal way of introduction to Dali: what Dali himself tells us and keeps repeating to us obstinately, untiringly, by means of his painting, his writing, his remarks: lectures, pronouncements, interviews, commentaries, books.*

*Unfortunately, we are so conditioned by a conformism which identifies science or philosophy with serious and boring matters that Dali's jubilant verve, expansive passion, and uncomplicated humor set us adrift and distract us from the essential and steer us toward the label of* exhibitionism and mystification, *which are safer for the public: this same public was reassured until just recently by exactly the same thing when confronted with the spectacle of Picasso's "horrible" and "delirious" faces.*

*Certainly there is really a Dali "case,"* a psychopathological case. *But if the public agreed to hear his case from his own lips, and not only receive reports about his eccentricities, it would discover an unknown Dali, secret, passionate, and, moreover, just as public and visible as the other, since the one cannot express itself without expressing the other.* \*

### The Image of the Body
*and the original traumatic situation.*
*Dali, as a little child, made a very bad start in life, very bad indeed, at the end of a true hallucinogenic series of chance occurrences on which his sensitive nature and his imagination will be forever fastened, blocking prematurely the normal course of the development of his personality.*

**It so happened that** *three years before Dali's, birth, another little Dali, seven years old, died of meningitis.*

**It so happened that** *Dali resembled this other child "like a mirror image"; they were as alike as twins.*

(Dali: *Secret Life*)

**It so happened that** *his despairing parents, hopelessly* fixed *on this first*

---

\* We take up the Dali " case " in the perspective of the royal way (to study it the way one studies a text of Plato or Freud) in two works : " Gala-Dali—The Divine Twins " in collaboration with S. Dali, and " Psychology of Modern Art—Morphology—Stylistics—Aesthetics, " the basis of our course at the Sorbonne, 1969-70. Here we explain this unknown and yet principal notion of the Sciences of Man: the notion of the corporeal scheme known as the " Image of the Body. "

Dali, committed the crime of giving the same first name to the new Dali that their dead son had born.

**It so happened that,** in the bedroom of the parents of the second Dali, in that room so frightfully "charged" and invested with the most mysterious activities, the most luring but also the most incomprehensible, dangerous, and redoutable, forbidden, in this sacred place of contradictory emotions, a large photograph of the dead Dali, the double and identical twin of the other, was enshrined high on the wall: the new little Dali who contemplated it was fascinated by what he was told about it every day.

**It so happened besides,** a fabulous coincidence, that next to the dead Dali and keeping him company, Dali the father, though a fanatical and unconditional atheist, had carefully placed another picture of a cadaver: a reproduction of Christ crucified, painted by Velázquez ! It is quite probable that, unbeknownst to this fanatical anti-Christ, Dali's mother, the nurse Lucia, and a maid, if not all of them, had explained to the little boy that this dead Dali had "ascended" even higher in heaven to rejoin the other crucified corpse. Such stories are quite plausible, since he suggests it: the actual identification with his dead brother and with Christ rising toward heaven. (Dali: *Secret Life*, pp. 152-53)

**It so happened also** that a series of accidents as unbelievable as absurd contributed to this illusion: the given name of this atheist father also referred to Christ, Salvador, and this same name was given to the first little Dali, and therefore also to the second one—but this first name of Saviour was a mockery which was going to make the little Dali into a cadaver, the only living one in this delirious and true story! These four saviours—dead, dying, or deadened— were they not a little too much for this young pristine being who was discovering the world, life, a qualm of conscience, who was trying to assemble the scattered pieces gathered from the exterior world in order to build and develop a coherent whole? One cannot build oneself without projecting oneself,

*without identifying oneself to real props, and what did he find in this place of privileged identification, mama and papa's bedroom? The invading images of two dead people, of two cadavers, twins by their proximity, their position on the wall, by death, by their ascension to heaven, by their same name, by their same celestial destiny. During all these first years when sensitivity, emotion, and the imaginary combine to fashion the person and the corporeal diagram, prop, and model, director of all behavior present and future of all affective intellectual and aesthetic categories to come, the fate of little Salvador is caught in this game of mirrors, of mirages, of doubles, and of imaginary twins that the Saviours, dead and living, send back one to another up to four!* (Dali: *Secret Life,* pp. 148-49; 151-52)

**And it so happens also indeed that,** *as far back as Dali's memory goes, and it is phenomenal, only comparisons, references to the dead Salvador, loom up. For example, were he to go out, his mother would let slip this remark: "Take a muffler, cover yourself up; if not, you'll die like your brother who took cold and died of meningitis." This dead boy, this cadaver, became his norm of life: he was obliged not to live, exist, act, or think except in relation to this dead Salvador: the rape and robbery of a being, of a conscience, of a person. It is extraordinary to confirm how much his life and his destiny correspond to the phenomenological descriptions of Jean-Paul Sartre. The primordial plight of "the being in the world" of Dali, his plan, his destiny, the directional scheme of his acts, his projects, of his "image of the body" can only be those of a mirage, of an illusion, of an appearance, of a lack of being, of a "hole" of the being, of a false resemblance, of a simulacrum, of a mimetism: the being that he was called to become, to be, found itself to be another: this other Salvador, the true one, that is, a dead person, an image, had stolen it from him. But then, among all these Salvadors, who was he himself?—A proxy, an interim, a surplus dead person—Not a solid, compact and hard reality, but a reply, a double, an absence, a hole of the unreal, of the imaginary, of the blurry, of the soft, whose vague, ambiguous,*

ambivalent, polyvalent contours fuse with the exterior world, with objects, with the landscape because of the radiation from this privileged space, this dynamic center of the imaginary, of the dead, suspended in front of him between heaven and earth, and from which, henceforward, the conscience, the thoughts, and the imagination of Salvador number IV unfold. *

**It happened also** that the series of impossible "objective chances" persisted and two miracles came to save the Saviour.

**In the first place,** it so happened that this Salvador number IV was a prodigious "psychic athlete," armed with ingenious mechanical defenses, out of the ordinary in quality and quantity.

**It so happened finally** that he "again found" on his path his identical twin in the shape that could truly save him, in the perfect complementary form, of real, living, present, acting matter: Gala, symmetrical image reversed in the mirror, of the unreal twin of antimatter, with whom Dali had been forced to

identify himself. It was this twin of actual living matter that Dali had to meet so that, like Lewis Carroll's Alice, he could come out himself from the mirage of the unreality of his own antimatter, to return to reality, that is, to go through his looking glass, free himself from his psychosis, to find himself cured: from this evolve the three phases of his life, of his thought, and of the works he has painted.

## DALI
**before**    up to 1929
## GALA

The Aesthetic of the Soft,
The Conquest of the Irrational.

*On the one side, the little Salvador, deprived of his own personal being, forcibly identified with an image, with an appearance of being, is condemned to the being of the appearance, that is, to what it seems to be, which accounts for:*
*Exhibitionism,*
*Dandyism,*
*Depersonalization.*
*On the other hand: forcibly identified with a dead boy, his "image of the body"*

---

* Each one of these notions has its corresponding plastic form here. Be it the *hallucinatory Aesthetics*, with the themes of replies (pp. 148-51), of the mirage and of the illusion of a visage in the landscape (pp. 58-59), of the polyvalent reading of a double picture (pp. 118-19), of the " hole " of the being (p. 144). Be it the *Aesthetics of the Soft*, by the soft swelling (pp. 127-32), by the softening and stretching out (pp. 126-27;146-47), by the soft mortification (pp. 112-13; 130-31), by the laceration of the flesh (pp. 13, 53, 143), or the particulate explosion (pp. 50-51; 56-57).

is that of a cadaver of soft flesh, putre-
fied and rotting, from which all sorts of
painted obsessions arise—dead animals,
putrefying, gnawed by worms and insects,
of soft flesh and even of soft bones.
The sexual obsessions are those of soft
swellings and not of hard erections.
These softened forms are stretched out,
are drawn out, reproducing the same
sort of elongated forms which are
caused by taking hallucinogenic drugs.
What saves and keeps Dali from going
crazy is this thin background of reality:
the crutches which allow this limp image
to stand up anyhow. Everywhere else
the imaginary triumphs over reality, he
"sees" at will quasi-hallucinatory visions
which he likes to conjure up, he even
sees through real intervening obstacles:
walls, the back of his nurse into which
a hole has been cut by his penetrating
gaze whence comes his hallucinogenic
power without the aid of hallucinogenic
drugs.
For Dali the absolute and vital urgency
is complete cosmic and transcendental
refusal of this death which has been
imposed on him. To conquer death
was, is, and will always remain the
central problem of Dali's life. After an

attempt at homosexual identification,
normal at this age, to his dead twin in
the form of a friend at Butchaquès
school, the last path of his discovered
salvation was to substitute for his
identification with the dead twin an
identification which conformed at the
same time to the laws of life and to
the sexual instincts, while identifying
himself no longer to a dead male twin
but to a living female twin, as the
repeated visions of Dulla-Dúllita - Gal-
lutchka bear witness: in Russian sleigh
scenes in the snow, described in the
Secret Life. But these identifications
were only lived in the imaginary realm
of fantasy, and not in the reality of a
real life relationship with a real living
person, and, for that reason, all the
attempts at autotherapy described in
the Secret Life were bound to fail:
Dali remained truly identified with a
real dead twin: he scarcely lived, at
the most he survived, on the verge of
madness toward which he lucidly felt
himsef wending his way during the
beautiful summer of 1929 in Cadaquès.

## DALI
## and
## GALA

Summer 1929

From the "Conquest of the Irrational" to the "Rational Conquest of Reality."

*The therapeutic miracle that came to him in flesh and blood was his girl-twin, his exact replica, real and Russian, she the Dulla-Dullita of his childhood: this was the moment of truth, the passing through the looking glass of his psychosis, which separated him from reality, brought about this time not by the soft and limp inconsistency of the imaginary Galas, but through the hard and implacable reality of a Gala who had lived and felt, was present and living in his being, through a very real "transference" of psychoanalytical type, with the inevitable repercussion of the ancient and original identification to the dead twin, reactivated in a paroxysm of the anguish of death, in terrifying hallucinogenic visions where Gala: a savage beast—a lioness—was going to tear him to shreds and devour him. But far from being "eaten" by Gala, it is Dali who will eat her, while eating through her reality, according to a typical mechanism of symbolic realization, of a desire, unobtainable in any other fashion.*

*Divested of these two ambiguous dead persons, the image of his body regained through the Twins of Life, Dali, exultant, decides henceforward to sign his name as "Gala-Dali," thus discovering by instinct that important truth known to psychiatrists and anthropologists: "the name makes the man."*

## GALA-DALI after 1941

Renaissance: Reality and Classicism.

*Undoubtedly Dali still remains provided with an imaginary paranoiac being, with the image of a disintegrated body, but now it is the couple, the living twins, "Gala-Dali," a classical delirium, hard-soft, who lives, speaks, and paints the re-found reality rationally: the thin crutches have become the "Glorious Galinian Body—the Classical Cupola" of his renaissance, and solidly "armed" by this protective fortress, he finds the historical realities of his inspirations now all drawn systematically from the*

most objectively true reality, but also the most objectively delirious for classical thought: the most recent and fantastic discoveries of nuclear physics and of molecular biological genetics. As time passes, they will be: the nuclear disintegrations of quantum physics, through the molecular brushstroke of Meissonier; the molecular biological structures of dioxyribonucleic acid.
The hallucinogenic disintegration of psychedelic pop orchestras (pp.146-47).
The "moiré patterns of Op Art and of the laser beam of cybernetic holograms." *
Dali himself wished to choose and arrange the works reproduced here. Through the planetary, molecular, monarchical, hallucinogenic, futuristic themes of exterior living reality the disintegrated remains of the image of the dead brother stand out in profile, to be completed after recalling the dreams and obsessions, in an infinite play of mirrored reflections of the multiple images of Venus (pp. 150-51); reappearances of Dulla-Dullita, imaginary female twins of childhood, in this grandiose finale, in this cosmic apotheosis of all Dalinian mythology, in the center of the world which is the railway station at Perpignan: throwing mother and father aside, at whose feet lie the remains of the dead twin boys (the two sacks of potatoes), symbols of Victory over Death, leaving the butterfly Mao, symbol of the paternal lineage —Stalin—Lenin—William Tell (pp. 152-53), the Divine Dioscuri, in a state of nongravitation, join at last in heaven their childhood companion **: Velázquez' "Christ" next to the Ideal Father at last re-found in a reconciliation, Love and Eternity.

---

 * According to Quillet: " Holograms: the reticular optical image of an object lighted by a laser beam and giving the integral illusion of relief. " The latest techniques use a computer and very sophisticated cybernetic effects.

 ** The initiated will feel the virtual omnipresence of Urspiel because here we are back again at the umbilical center of our point of departure: his parents' bedroom. We will justify our discretion by a more detailed study later on.

# The Planetarian Dali

pages 5 to 36

Twenty-five years ago, the Spanish author
Ramon Asnar wrote :
" The first man on the moon will be
neither a Russian nor an American, but
a Spaniard.
" This Spaniard WILL BE NAMED DALI,
who, from his very earliest adolescence,
painted fabulous and rugged landscapes
where black and dazzling shadows are

cast in lunar space without atmosphere."
But other worlds exist, still unexplored,
that men have never seen. They are
all concentrated on a single planet-
Earth. Thus, the first macrocosm that I
painted was a Phoenician jug (page 26).
In the curves of the terra cotta I saw the
water of my life flow by, being filled
with data through the big hole and quench-
ing my thirst through the little hole.
In the same way, the planet Earth changes
itself into a fluid computer.
When the snobs of modern art acclaim
each new change in aesthetics as prog-
ress, they do not know whether the
successive phases of these mutations will
be as unalterable as those of the moon.
They should be taught to know whether
these phases of art tend toward the full
moon, or whether they lead to nothing,
as does that minimal art which has
now reached zero.
Thus DALI cannot yet be seen; he is for
the moment in a phase of the new moon,
from which he will soon emerge.

## 13 Birth of a Goddess
1960
(Detail)
Oil on panel
13 1/8×10 3/8".
*Collection Mrs. Henry J. Heinz II*
*New York City*

## 14-15 Aerodynamic Nude Deformed by the Action of the Moon on the Rising Tide
1934
Plaster

## 16-17 Big Thumb, Plate, Moon, and Decaying Bird
1928
(Detail)
Oil and gravel collage on fiberboard
19 3/4×24″
*Collection A. Reynolds Morse*

## 18 Nature Morte Vivante (Still Life—Fast-Moving)
1956
(Detail)
Oil on canvas
49 1/4×63″
*Collection Brad G. Morse*

19 **Dali, at the Age of Six, when He Believed Himself to Be a Young Girl, Lifting the Skin of the Water to Observe a Dog Sleeping in the Shadow of the Sea**
1950
(Detail)
10 3/4×13 3/8″
Collection Count François de Vallombreuse, Paris

20-21 **Imperial Violets**
1938
(Detail)
Oil on canvas
39 1/4×56 1/8″
Museum of Modern Art, New York City
Gift of Edward F. W. James, Sussex, England

22-23 **Pharmacist of Ampurdan in Search of Absolutely Nothing**
1936
Oil on panel
11 3/4×20 3/8″
Collection Edward F. W. James, Sussex, England

24 **View of Cadaques in the Shadow of Mount Pani**
1917
(Detail)
Oil on burlap
15 1/2×19″
Collection
Mr. & Mrs. A. Reynolds Morse

25 **The Average Bureaucrat**
1930
Oil on canvas
31 7/8×25 3/4″
Collection
Mr. & Mrs. A. Reynolds Morse

26 **Jug**
1922-1923
(Detail)
Oil on canvas
20 7/8×16 1/4″
Private collection

27 **Birth of Liquid Anxieties**
1932
(Detail)
Oil on canvas
21 1/8×15″
Galerie Petit, Paris

28-29 **Nuclear Cross**
1952
(Detail)
Oil on canvas
31 3/4×22 7/8″
Galerie Petit, Paris

30-31 **Echo in the Void**
1936
(Detail)
Oil on canvas
28 3/4×36 1/4″
Galerie Petit, Paris

32-33 **Symbiosis of Head of Shell fish**
1931
(Detail)
Oil on canvas
10 5/8×13 3/4″
Collection Daniel Filipacchi

34-35 **Honey Is Sweeter than Blood**
1928-29
(Detail)
Private collection, Paris

36 **The Great Masturbator**
1929
(Detail)
Oil on canvas
43 1/4×59 1/8″
Private collection, Paris

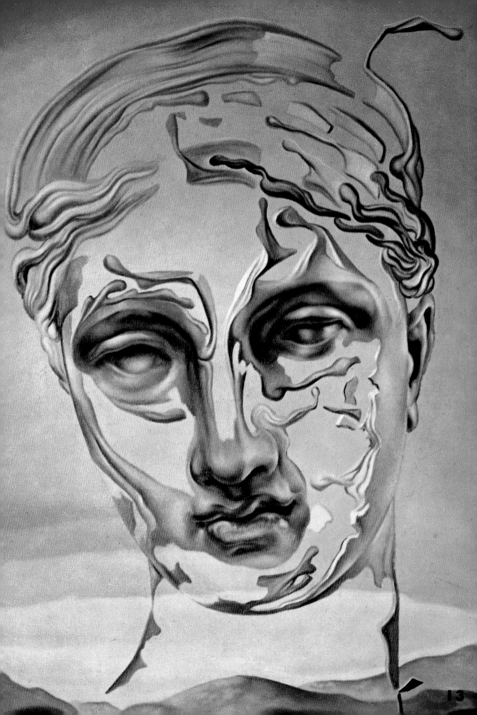

13

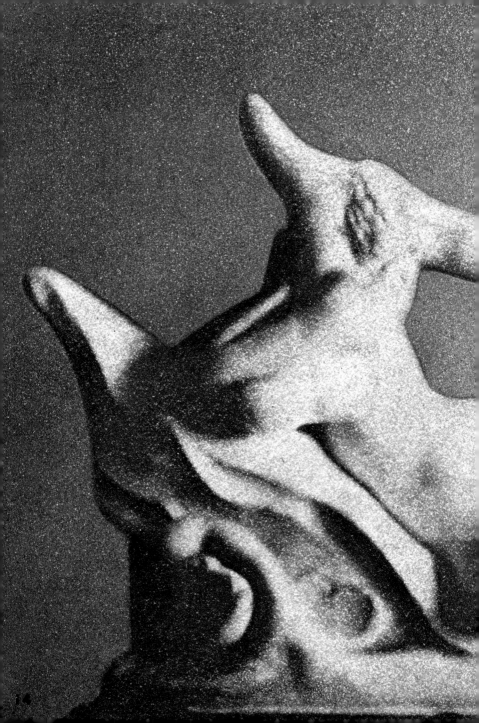

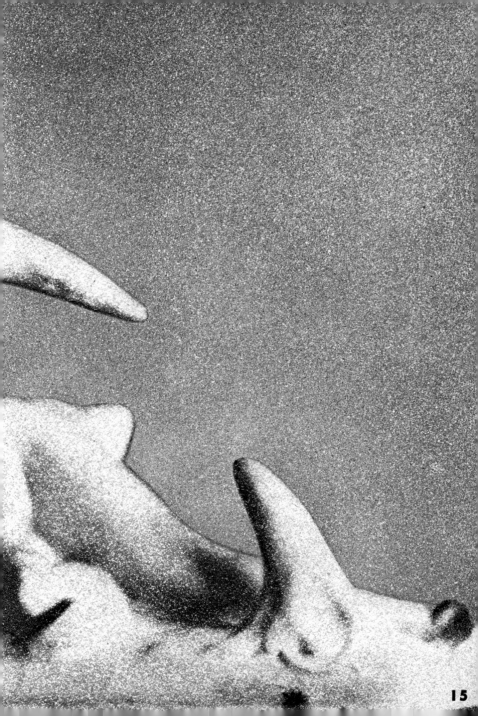

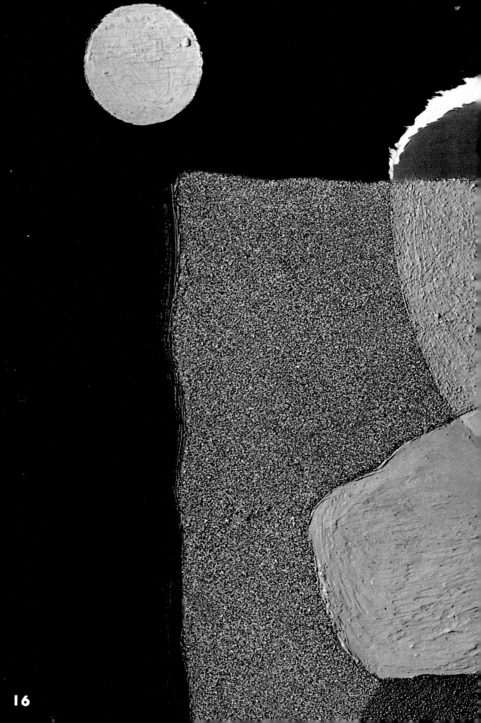

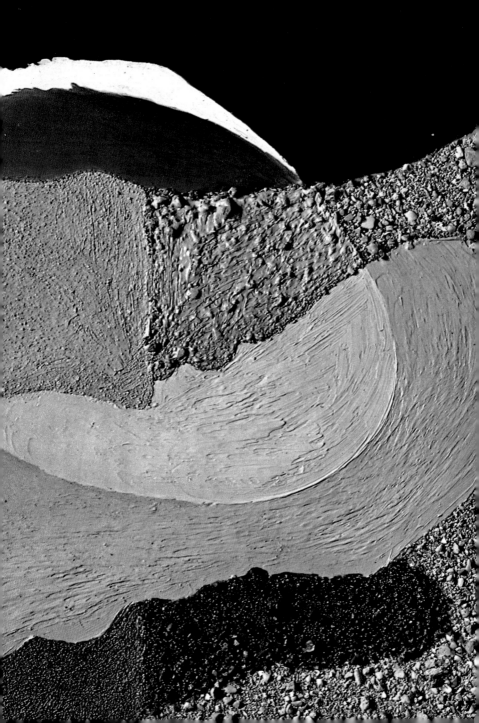

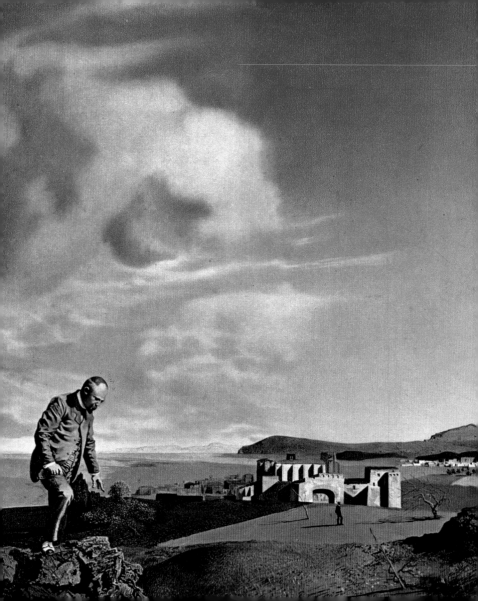

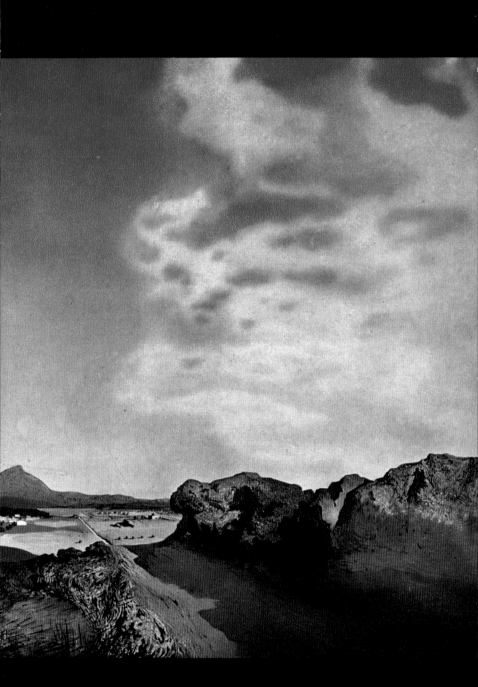

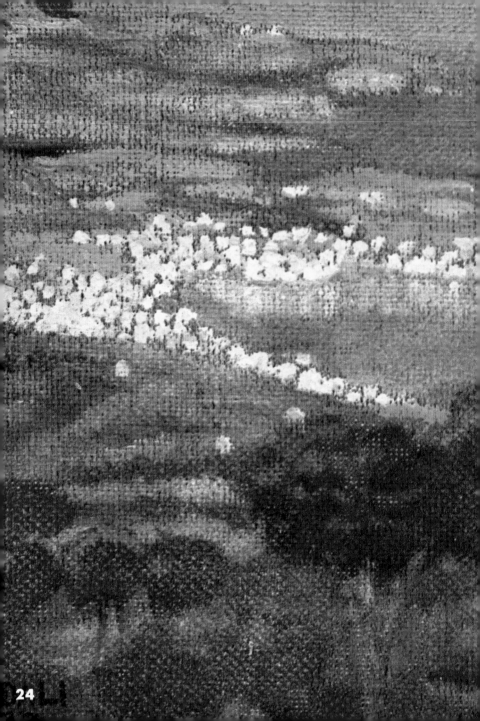

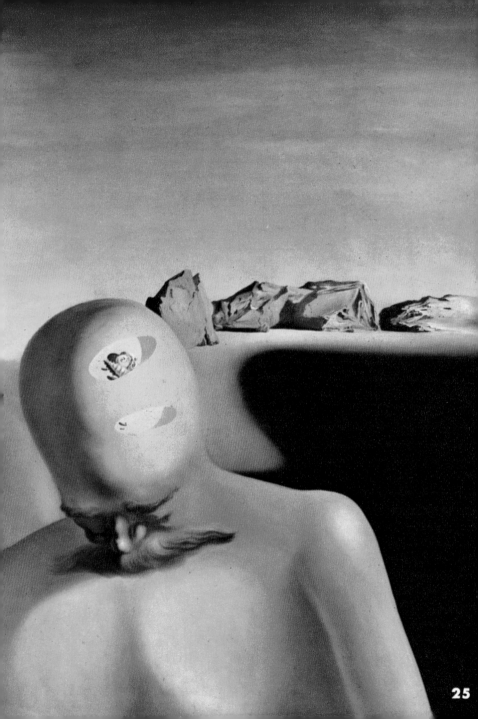

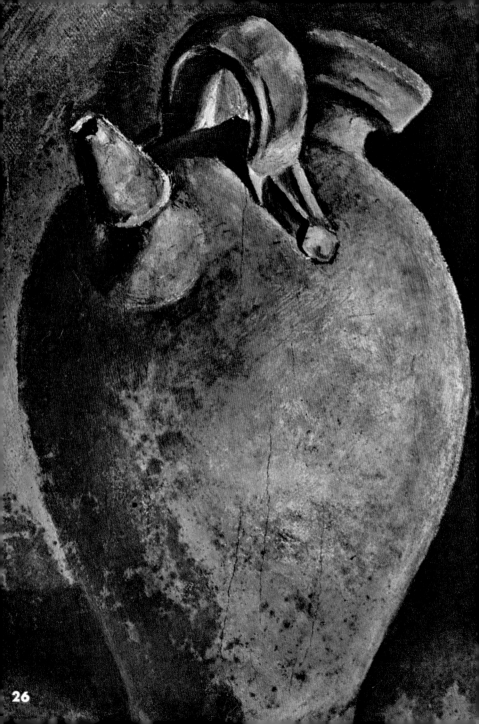

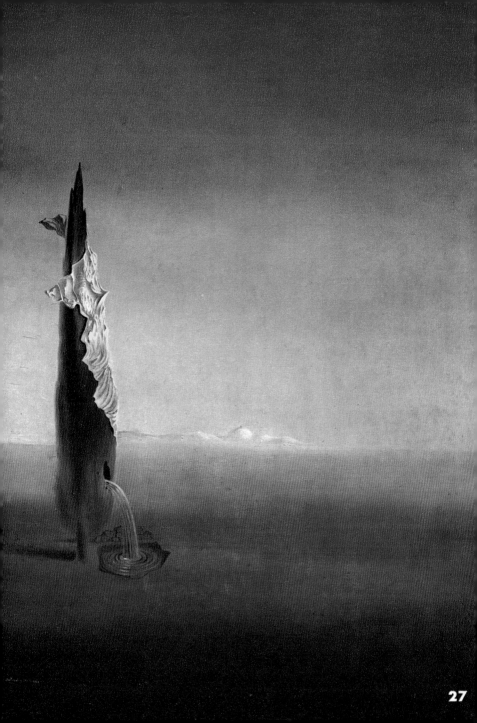

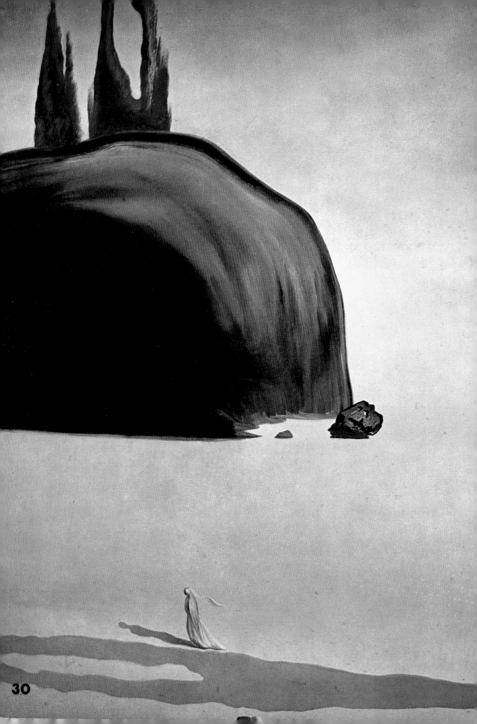

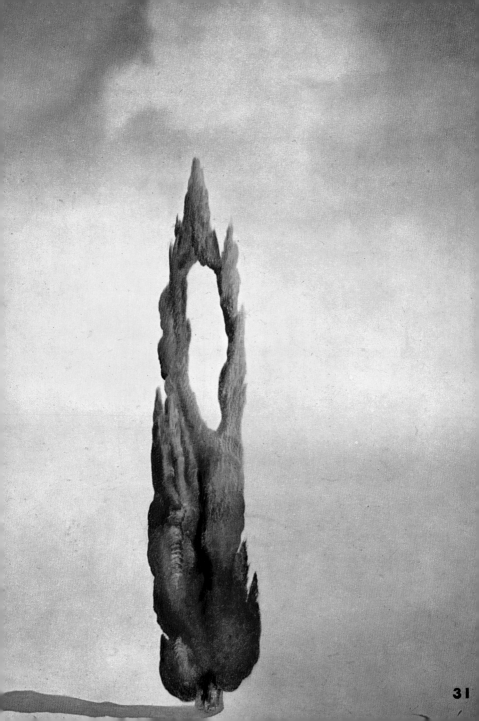

31

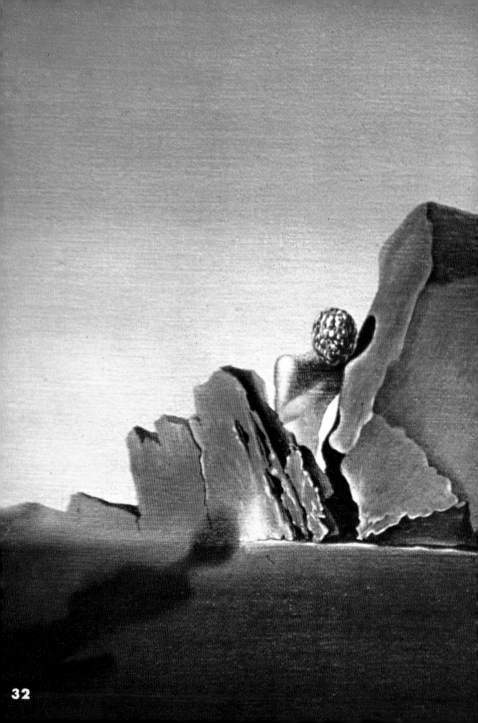

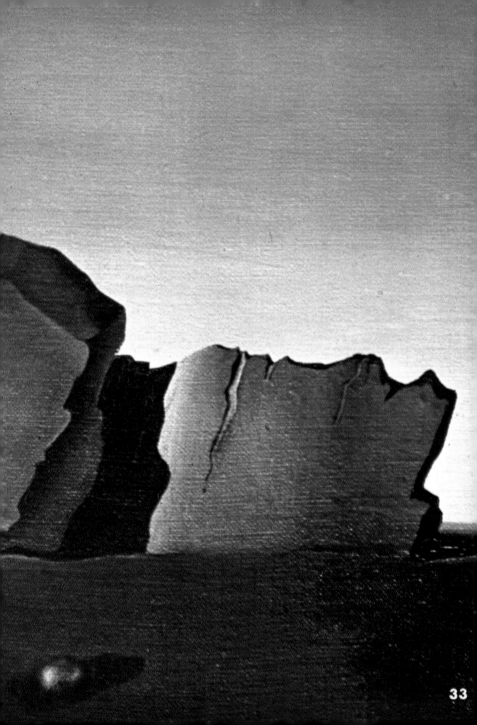

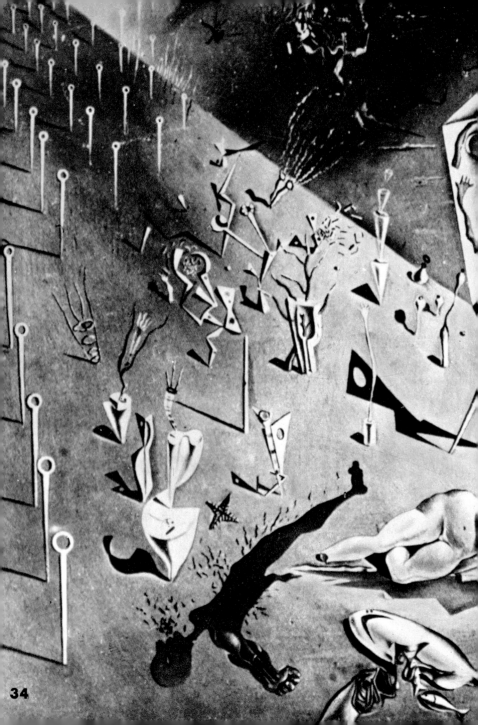

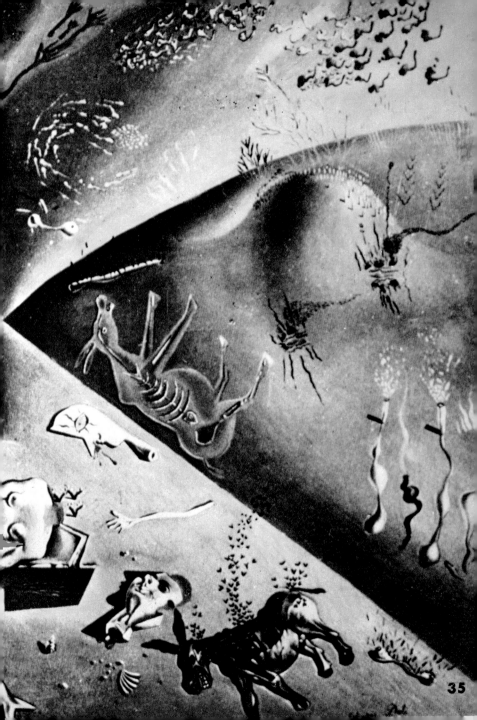

35

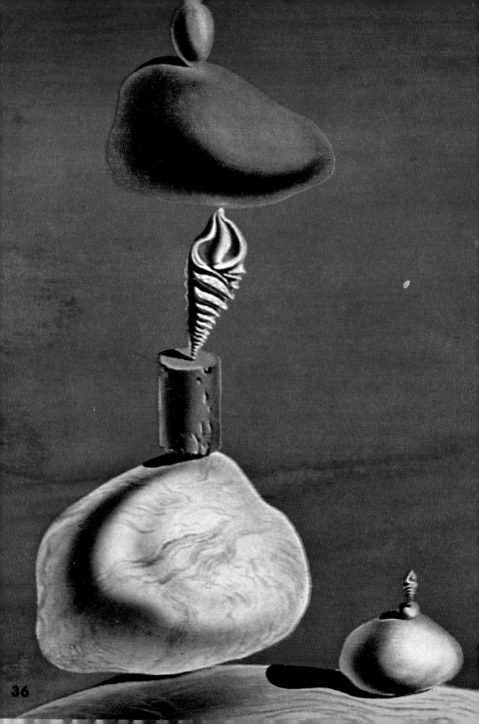

# The Molecular Dali

pages 37 to 60

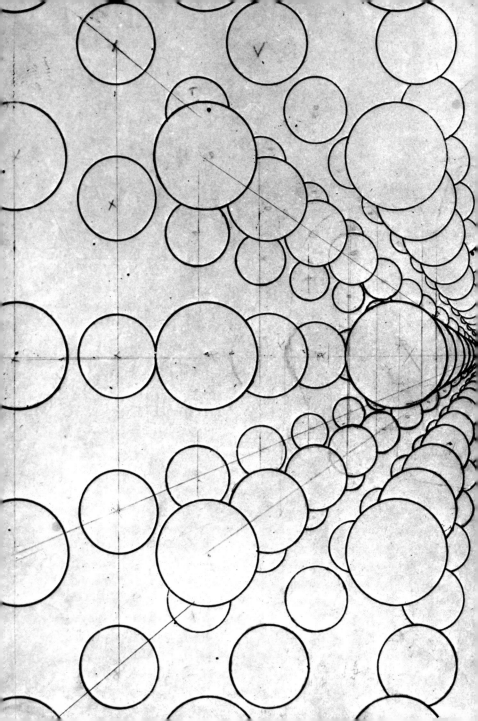

I began a happening in New York by announcing in front of three thousand spectators that Cézanne was a catastrophe of congenital awkwardness—a painter of decrepit structures of the past. I was applauded, principally because nobody knew who Cézanne was.

What must one think of a man who spent all his life trying to paint round apples, and who never succeeded in painting anything but convex apples? Imagine apples painted upside down; it's a real tragedy, is it not? One has to be extremely awkward to be content with painting apples that are such a failure that they cannot even be eaten. Dali declares that Cézanne is only a bricklayer : Cézanne never succeeded in painting a single apple capable of concealing—monarchistically—in its absolute volume the five regular geometric forms. And Dali repeats that Cézanne is a Neoplatonic mason capable, at most, of building a garage in cement—and not even square at that!

Le Corbusier also made a disgraceful mistake : never will reinforced cement be used on the other planets. Le Corbu, Le Corbubu, Le Corbi, Le Corba, Le Corbo dead, Le Corbousier died by drowning. Yes! Yes and yes, he sank like a stone, the weight of his own reinforced cement pulling him down like a masochistic Protestant Swiss cheese.

On a structural basis, Cézanne is like Le Corbusier; the only difference, between them is that Cézanne was a rabid reactionary and full of good intentions whereas Le Corbusier was irremediably Swiss, left wing, and full of bad intentions. Piñero, on the contrary, is an authentic Spanish genius : he conceived the sublime cupola of the Dali Museum in Figueras because, with Fuller, he is capable of making the molecular structures of deoxyribonucleic acid—ingredient of eternity—come to life. Buckminster Fuller has freed architecture from the right angle and has substituted for structures that are heavy others that seem to take

flight; he has demonstrated that the ideal shelter for man is a spherical translucid structure which might cover the earth—a cupola! This is an eminently monarchistic, vital, and liturgical principle. Dali says No to Le Corbusier and to Cézanne!

But Dali says Yes to Fuller and Piñero! Yes, because they are as light as the dandelion pappi whose angelic spheres will inevitably cover the interstellar deserts. In order to paint the illusionism of the most abjectly *arriviste* and irresistible of imitative art, Dali will have been the first to utilize the clever tricks of paralyzing *trompe l'œil* in oil, in color, and by hand, the virtual superfine extravagant hyperaesthetic images of the living molecular structures of the future—that is to say, the double spiral of Crick and Watson, Jacob's Ladder of genetic angels, the only structure linking Man to God.

**45 Superposition of the Molecular Structures of Crick and Watson Corresponding to the Battle of Tétuan**
(Detail)
(Pseudoscopic document, actual size)

**46-47 Galacidalacidesoxyribonucleic**
1963
(Detail)
Oil on canvas
10′×11′4″
*New England Merchants National Bank,
Boston, Massachusetts*

**48 Self-Portrait (Dali, Nude)**
1954
(Detail)
Oil on canvas
24×18″
*Private collection, Memphis*

**54-55 Arabs (Death of Ramon Lull)**
1963
(Detail)
Oil on panel
4 1/2×11 1/2″
*Collection Mrs. Abel E. Fagan Chicago, Illinois*

**49 Galacidalacidesoxy-ribonucleic**
1963
(Detail)
Oil on canvas
10′×11′4″
*New England Merchants National Bank, Boston, Massachusetts*

**56-57 The Ascension of Saint Cecilia**
1955
(Detail)
Oil on canvas
32×26″
*Private collection*

**50-51 Assumpta Corpuscularia Lapislazulina**
1952
(Detail)
Oil on canvas
90 1/2×56 3/4″
*Collection John Theodoracopoulos*

**58-59 The Three Sphinxes of Bikini**
1947
Oil on canvas
13 3/4×19 5/8″
*Galerie Petit, Paris*

**52-53 Tuna Fishing**
1966-67
(Detail)
Oil on canvas
11′2″×14′5″
*Paul Ricard Foundation*

**60 The Annunciation**
1956
(Detail)
Ink
17×22″
*Collection A. Reynolds Morse*

**44**

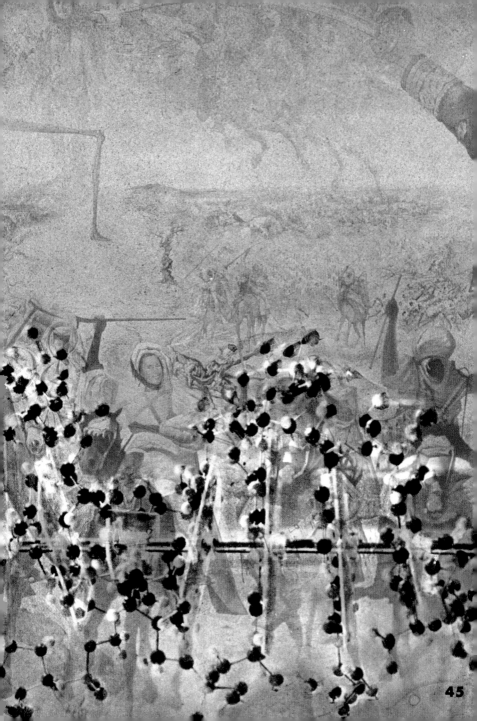

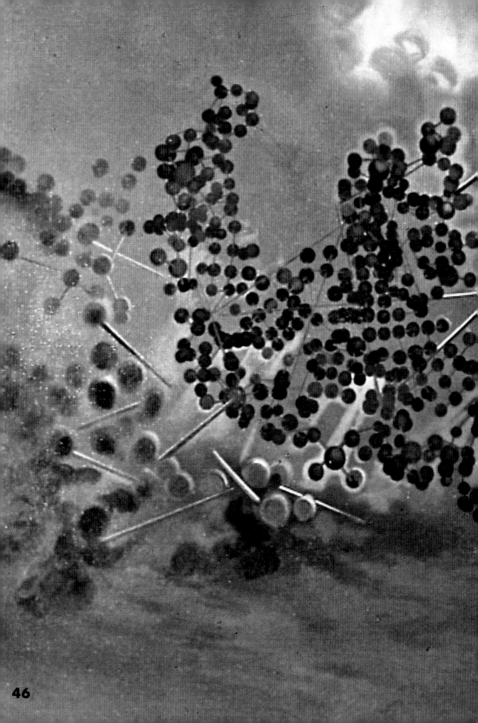

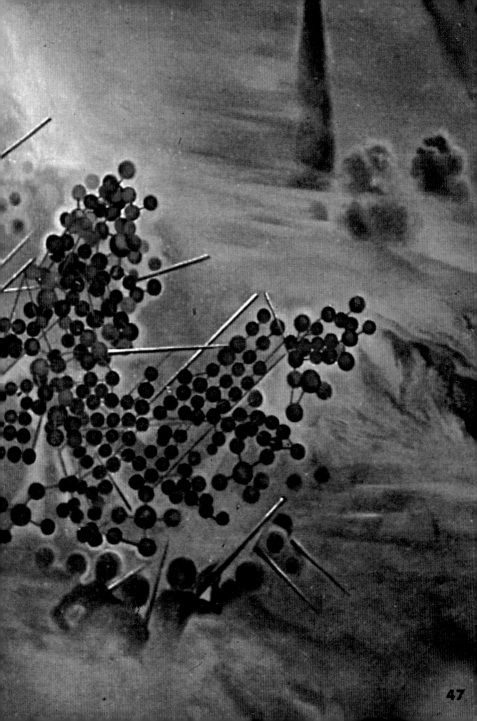

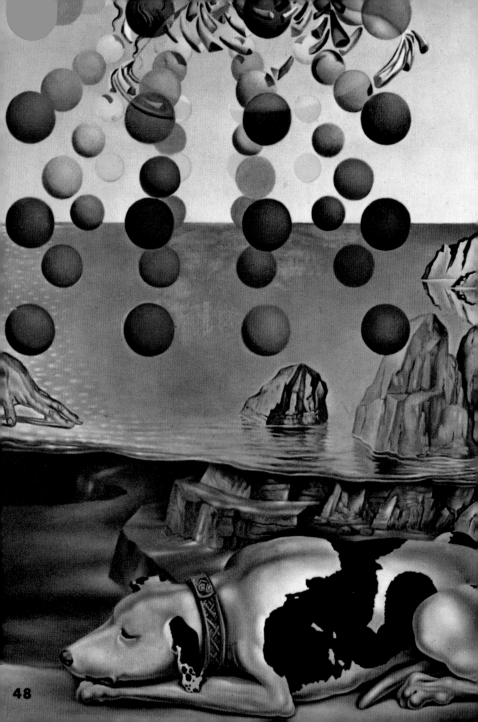

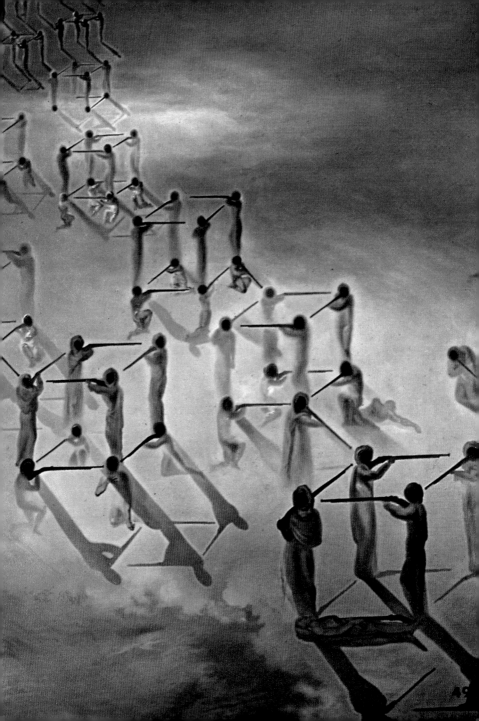

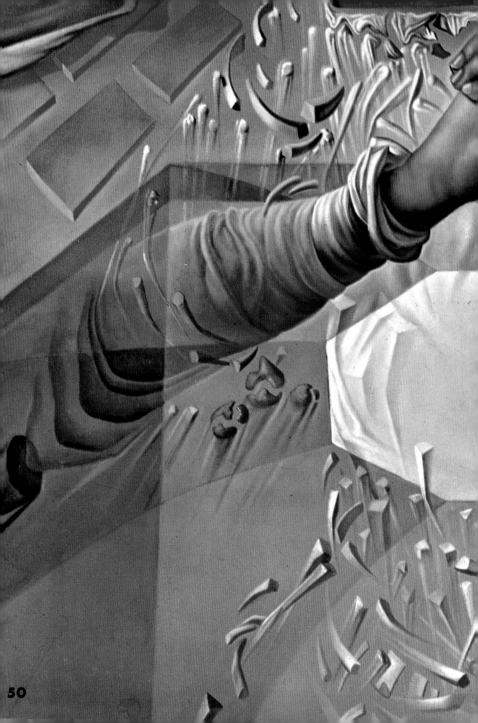

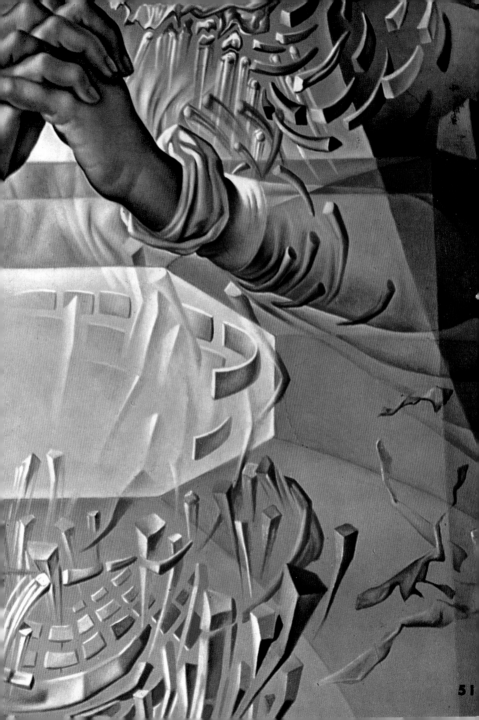

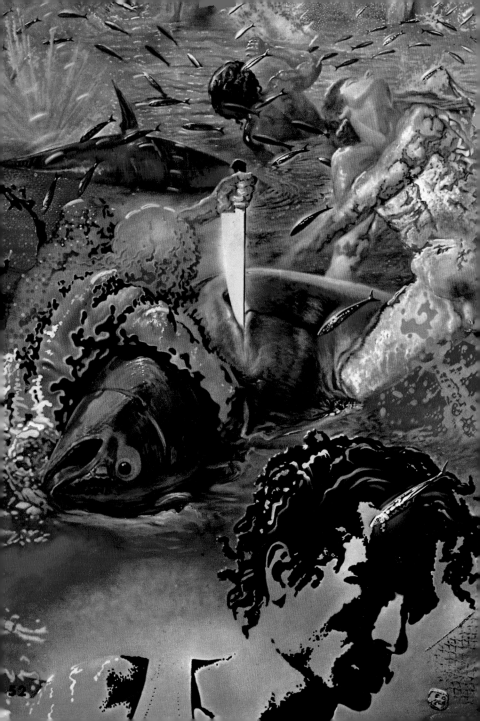

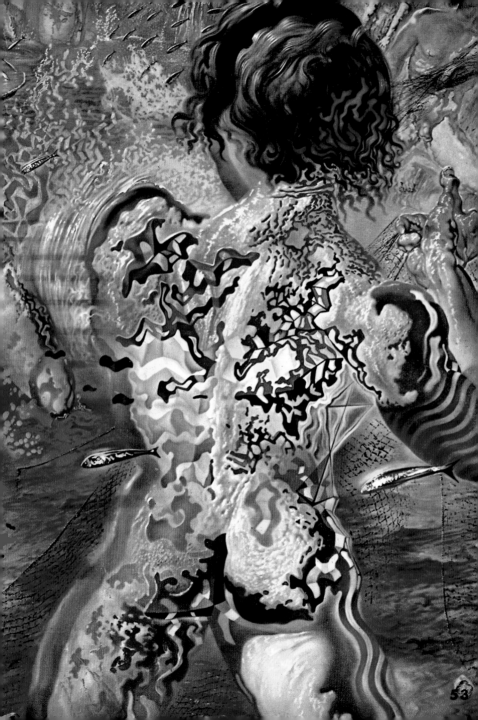

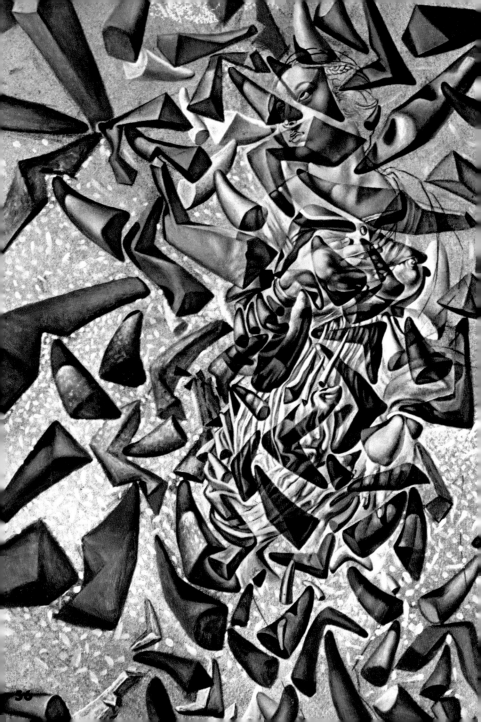

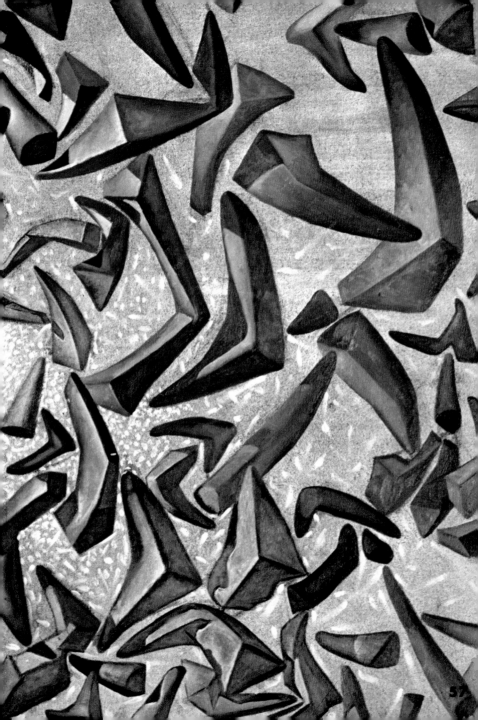

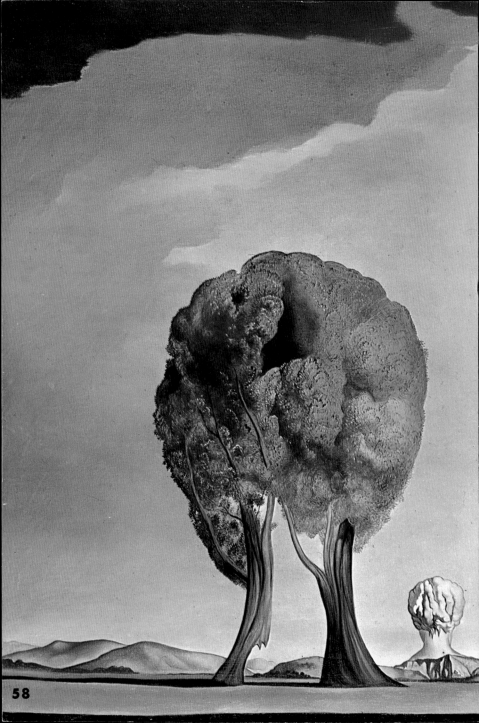

58

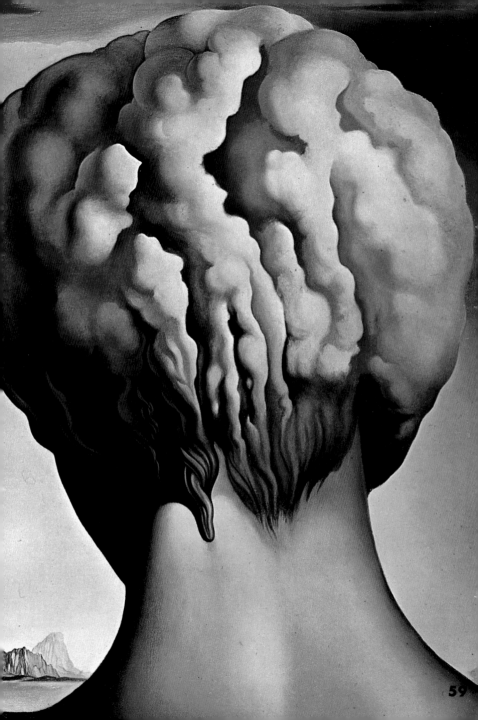

59

60

# The
# Monarchical
# Dali

pages 61 to 92

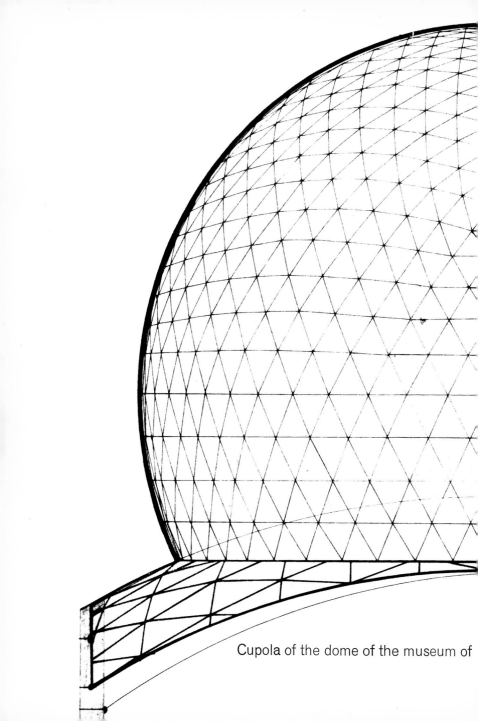

Cupola of the dome of the museum of

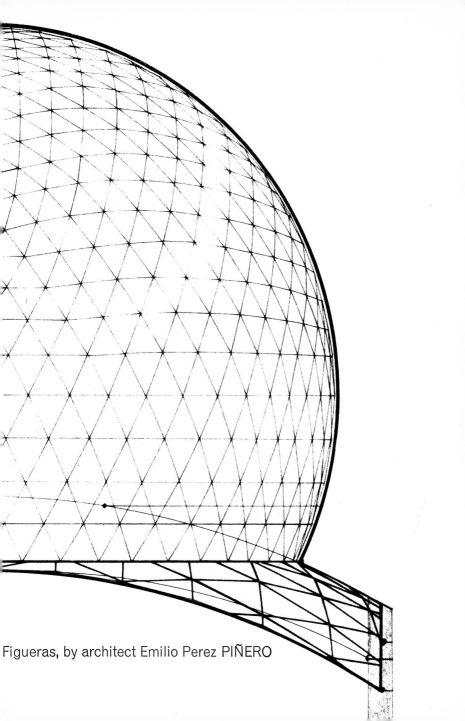

Figueras, by architect Emilio Perez PIÑERO

Most painters who seek recognition are acclaimed from the day they buy an expensive automobile. But their success is enhanced when to the possession of this car they can add the acquisition of a well-trained chauffeur.

Salvador Dali, monarchist and anarchist, and consequently opposed to a consumer society, is naturally against automobiles, to which he prefers a triumphal chariot and, instead of a chauffeur, a queen: GALA.

Let us beware of the contemporary art mess! Perhaps we are throwing away the best of it because the best is always hidden; so, to protect it, we should put an even greater treasure in front of it, just as I have put my greatest treasure, Gala, in front of this treasure, which is the imperialistic structure of my genius.

I have always been an anarchist and a monarchist at the same time. Let us not forget that two founders of anarchism were Prince Kropotkin and the princely

Bakunin. I am, and have always been, against the bourgeoisie. The true cultural revolution would be the reestablishment of monarchistic hierarchies.

Piñero, the greatest architect of any monarchy, lived during the royal hour of Spain's past glory, and, like his country, he possessed the art of balancing the concentric and the eccentric.

Ledoux had envisaged for the French people the architecture of absolute monarchy, that is, spherical architecture. The second great monarchistic architect is my good friend Buckminster Fuller, known throughout the world as the creator of the geodesic dome, who said that in Spain Piñero had created reticular domes based exclusively on a rigidity which he himself had been unable to discover. Fra Luca Pacioli also used to say : "Monarchy is a sphere." Thus, at the very hour of the reinstatement of the Spanish monarchy, the new monarchistic architecture of Piñero will make Nicolas Ledoux's dream of a spherical

house come true. (This house was never built because of the French Revolution.) The monarchistic tradition is precisely change and reinvention. In painting, it is using an ultraphotographic technique, for here the artist has spent months in order to portray his subject by means of the miraculous process of hand photography, where each stroke of the brush depends exclusively on his royal will, and where each stroke of the brush becomes monarchistically a fragment of eternity in an immortal structure.

**67**

## 74-75 Crucifixion (Corpus Hypercubus)
1954
(Detail)
Oil on canvas
76 1/2×48 3/4″
*The Metropolitan Museum of Art, New York City*
*Gift of the Chester Dale Collection, 1955*

## 76-77 Battle of Tétuan
1962
(Detail)
Oil on canvas
10′2″×13′4″
*Huntington Hartford Collection*

## 78-79 Necrophilic Springtime

## 80-81 Leda Atomica
1949
(Detail)
Oil on canvas
23 5/8×17 1/2″
*Private collection*

## 82-83 Automatic Beginning of a Portrait of Gala
1932
(Detail)
Oil on panel
6 1/4×5 1/4″
*Private collection*

## 84-85 Galatea of the Spheres
1952
(Detail)
Oil on canvas
25 5/8×21 3/8″
*Private collection*

## 86-87 Geodesic Portrait of Gala
1935
Oil on panel
12×14″
*Collection Edward F. W. James, Sussex, England*

## 88-89 The Royal Hour. Ceiling for the Alleusis Palace in Barcelona
1969
Oil
Diameter, 10 feet
*Property of the City of Barcelona*

## 90 Back of Nude
1945
(Detail)
**(Study for a portrait of the back of my wife contemplating an architectural form)**
Sanguine
18×24″
*Collection*
*Mr. & Mrs. John L. Loeb*

## 91 Study for "Galarina"
1945
(Detail)
Pencil
25 1/2×19 3/4″
*Private collection*

## 92 Gala (First Architectural Drawing)
1936
(Detail)
Pencil
15×13″
*Collection Lockwood Thompson, Cleveland, Ohio*

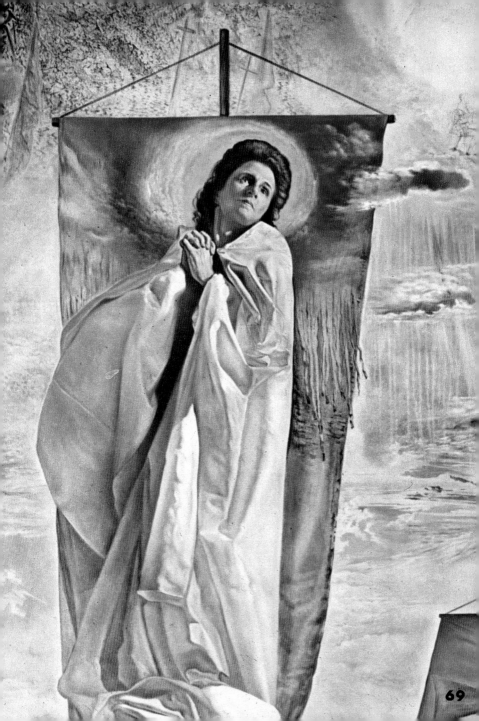

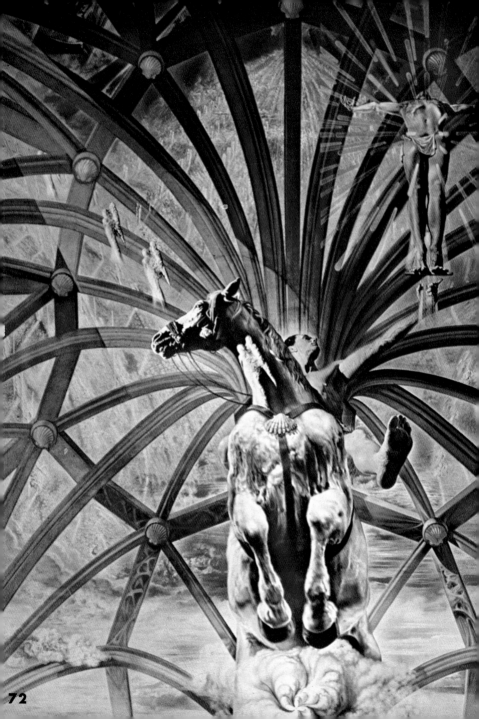

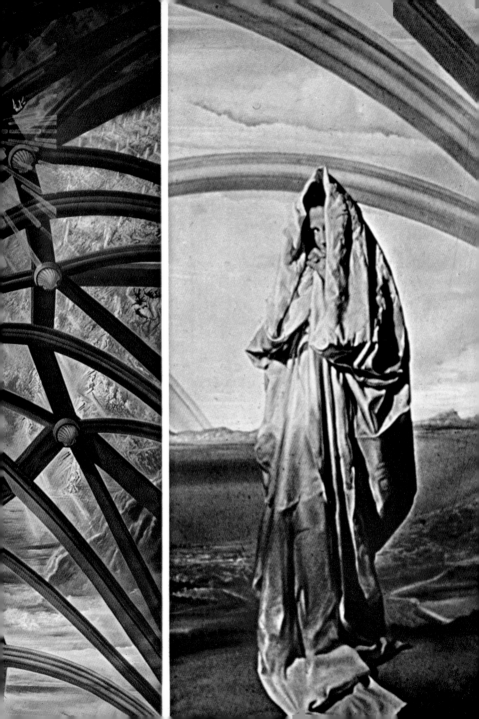

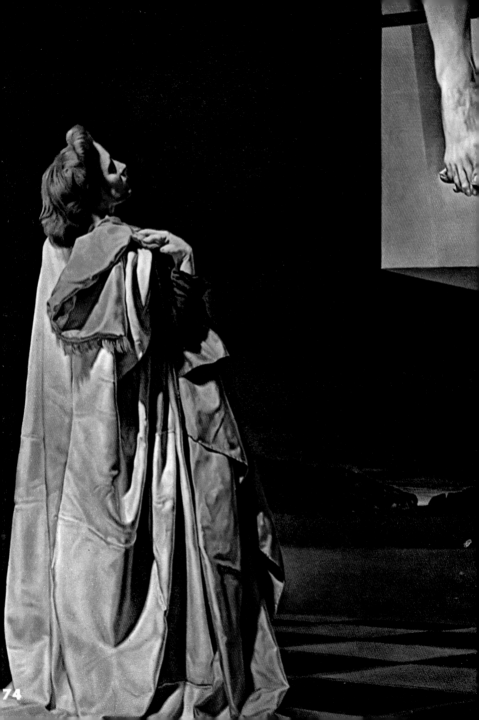

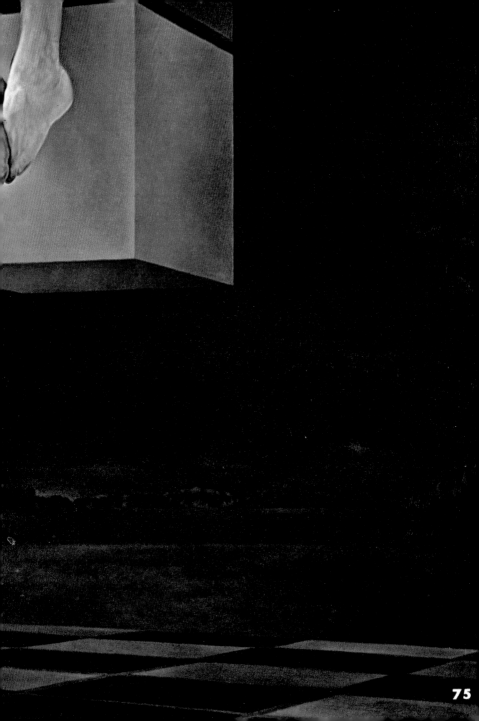

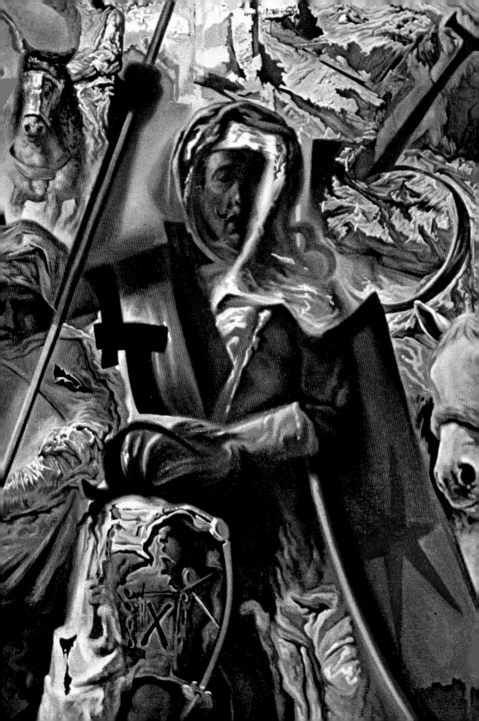

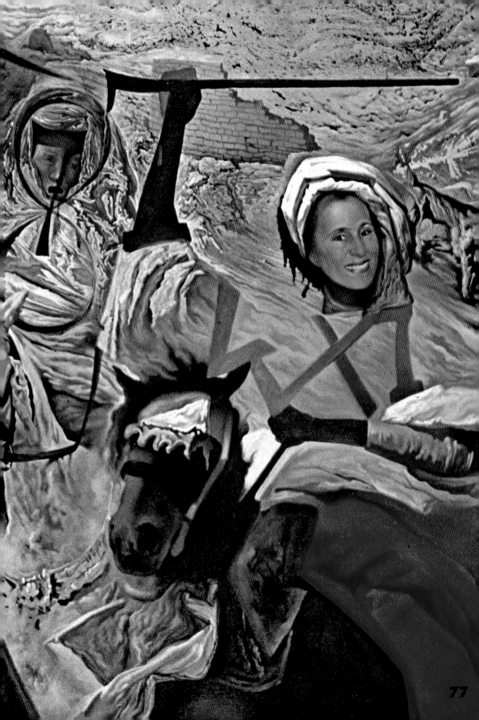

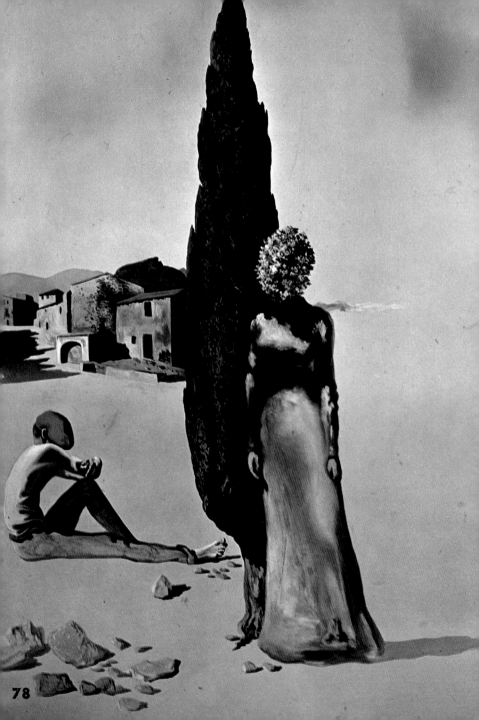

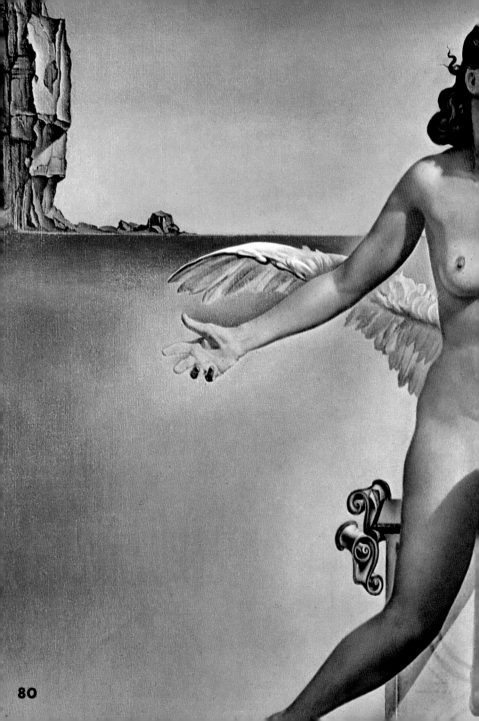

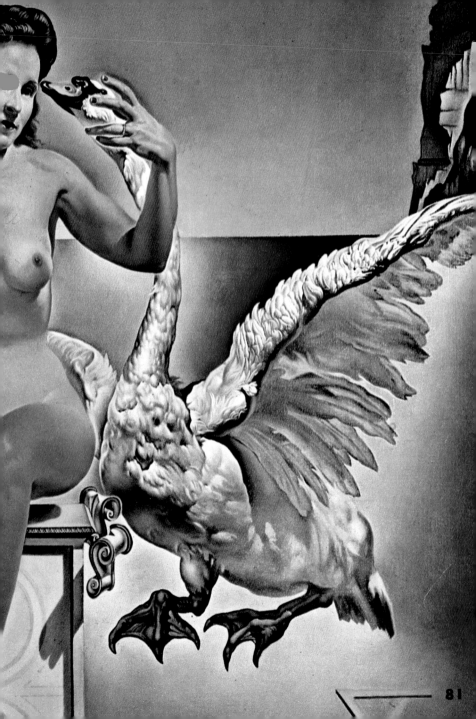

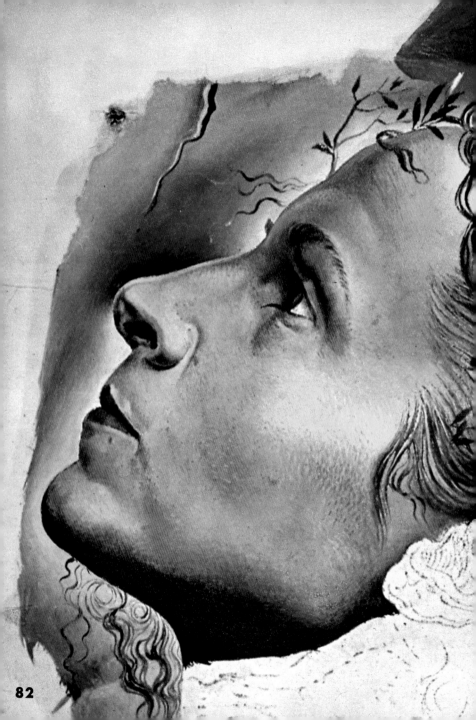

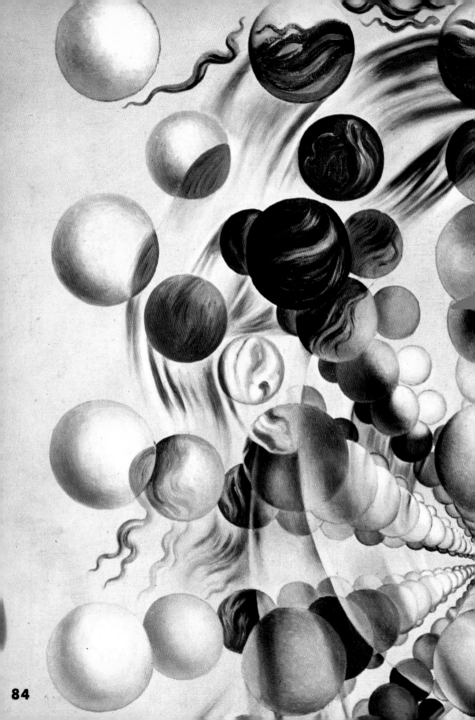

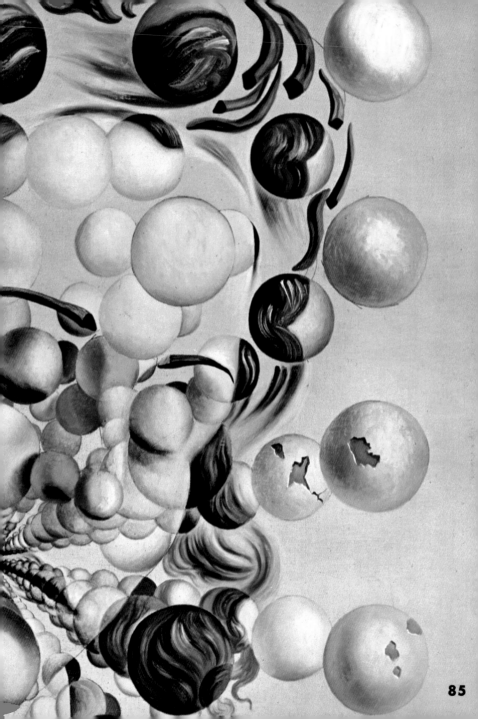

85

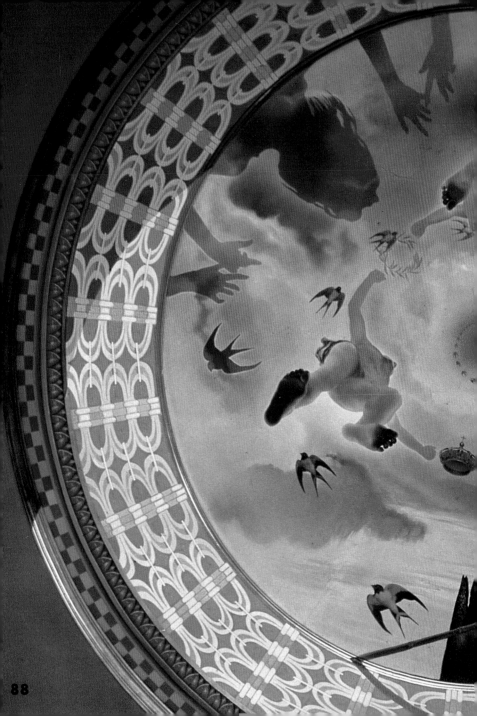

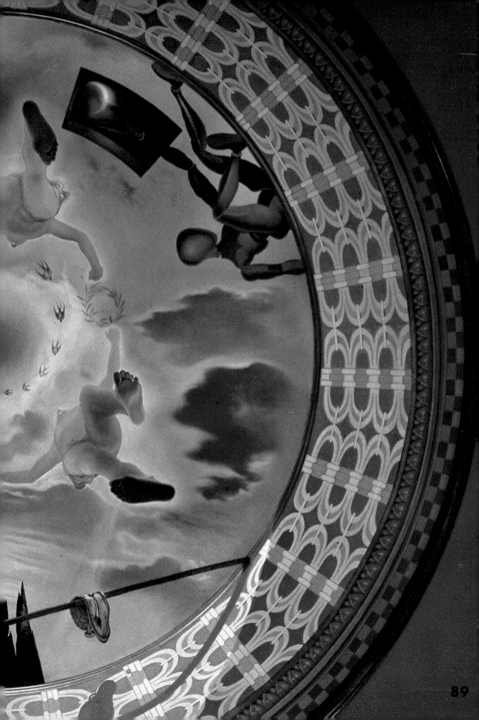

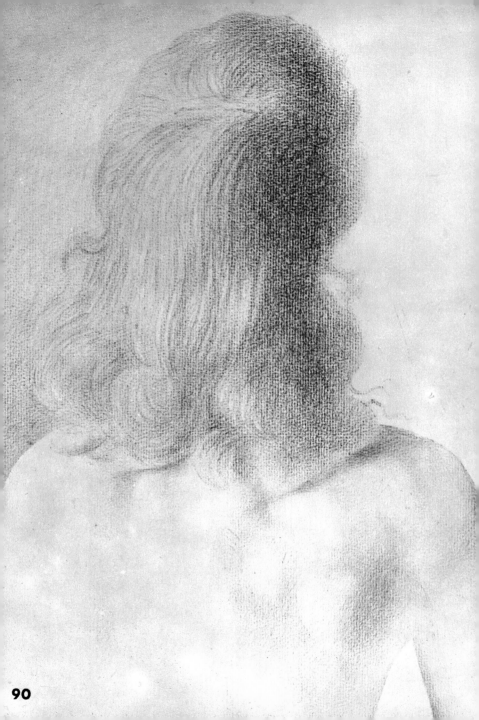

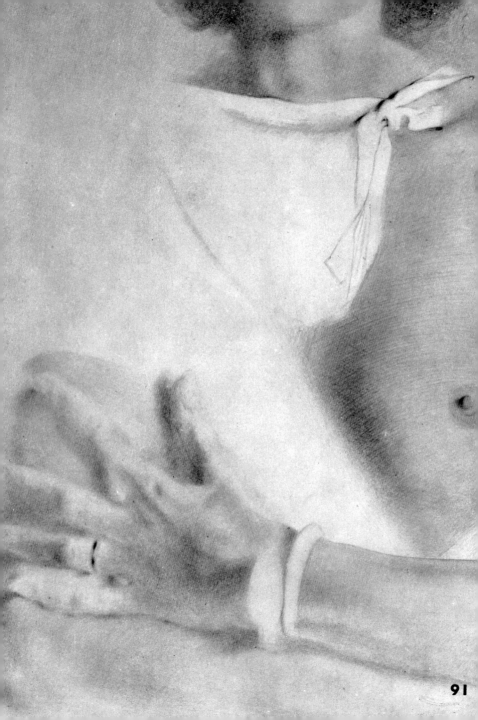

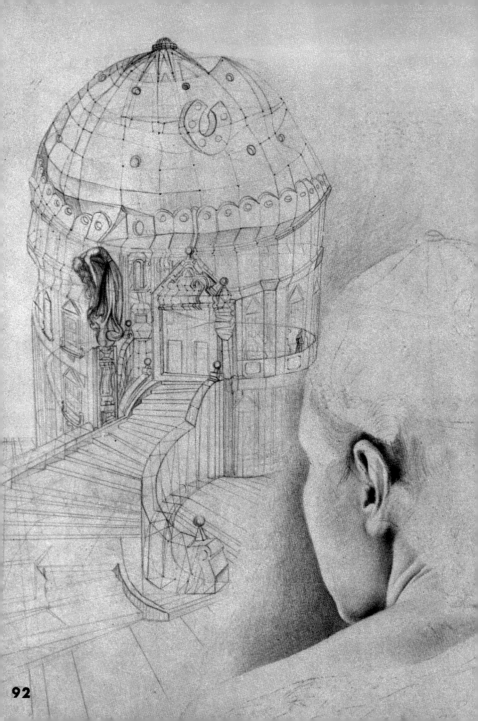

# The
# Hallucinogenic
# Dali

pages 93 to 132

DELACROIX

Amicus
amico —

el ultimo

PROFHETES
del
Romantismo

pour Emilio Puignau
en souvenir d'une cheminée de coin

au coin de la cheminée

Marcel Duchamp

Cadaqués 1968

Timothy Leary, the prophet of LSD, said: "Dali is the only painter of LSD without LSD." This is normal for one who tries to capture, with the most exacting fury of precision, the imagery of concrete irrationality. On the other hand, nothing in the world bores me more than those who have a habit of telling about their dreams or their hallucinations; not one of them is capable of bringing to life either the one or the other. For, if

the eye is a miraculous thing, it is necessary to know how to use it, as I have used mine; it has become a real, soft, and psychedelic camera. I can cause it to make photographic negatives, not of exterior things, but of the visions of my thoughts; thus, anyone capable of arousing his visions at will is unaware of the sorrow of all daily reality and can give free rein to the paranoiac magic of his own hallucinations.

Then why should Dali use drugs when he has discovered that our world is a world of people with hallucinations, where theories, like that of relativity, add to the three dimensions of space a fourth, which is time, the most surrealist and the most hallucinatory of spatial dimensions.

I have never taken drugs, since I am the drug.

I don't talk about my hallucinations, I evoke them.

Take me, I am the drug; take me, I am hallucinogenic!

**101 Profanation of the Host**
1929
(Detail)
Oil on canvas
39 3/8×28 3/4″
Collection
*Mr. & Mrs. A. Reynolds Morse*

**102-103 Afterimage of Laporte**
1932
(Detail)
Oil on canvas
42 7/8×31 1/2″
*Galerie Petit, Paris*

**104-105 Imperial Monument to a Child-Woman**
c. 1929 (unfinished)
(Detail)
Oil on canvas
56×32″
*Private collection*

**106-107 The First Days of Spring**
1929
(Detail)
Oil and collage on panel
19 3/4×25 5/8″
*Collection
Mr. & Mrs. A.
Reynolds Morse*

**116-117 Accommodations of Desire**
1929
(Detail)
Oil and collage on panel
8 5/8×13 3/4″
*Julien Levy Gallery*
*Bridgewater, Connecticut*

**118-119 Invisible Afghan with the Apparition on the Beach of the Bust of Garcia Lorca in the Form of a Compotier with Three Figs**

**120-121 Fifty Abstract Pictures which as Seen from Two Yards Change into Three Lenins Masquerading as Chinese and as Seen from Six Yards Appear as the Head of a Royal Tiger**
1963
(Detail)
Oil on canvas
79×90″
*Private collection*

**122-123 Ordinary French Bread with Two Fried Eggs, Without a Plate, on Horseback, Trying to Sodomize a Crumb of Portuguese Bread**
1932
Oil on wood
6 1/4×12 5/8″
*Galerie Petit, Paris*

**124-125 Piano Fountain**
1933
Oil on canvas
7 1/2×9 1/2″
*Private collection*

**126-127 Cannibalism of Objects with Simultaneous Crushing of a Violoncello**
1933
(Detail)
Charcoal drawing touched up with white chalk
*Private collection*

**128-129 Soft Construction with Boiled Beans (Premonition of Civil War)**
1936
(Detail)
Oil on canvas
39 3/8×39″
*Philadelphia Museum of Art*
*Louise and Walter Arensberg*
*Collection*

**130-131 Soft Self-Portrait with Fried Bacon**
1941
(Detail)
Oil on canvas
24×20″
*Private collection*

**132 Average Fine and Invisible Harp**
1932
Oil on panel
8 1/4×6 1/4″
*Private collection*

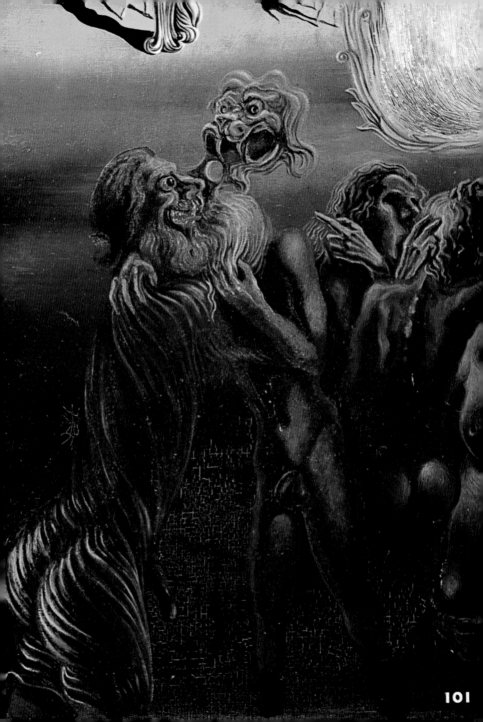

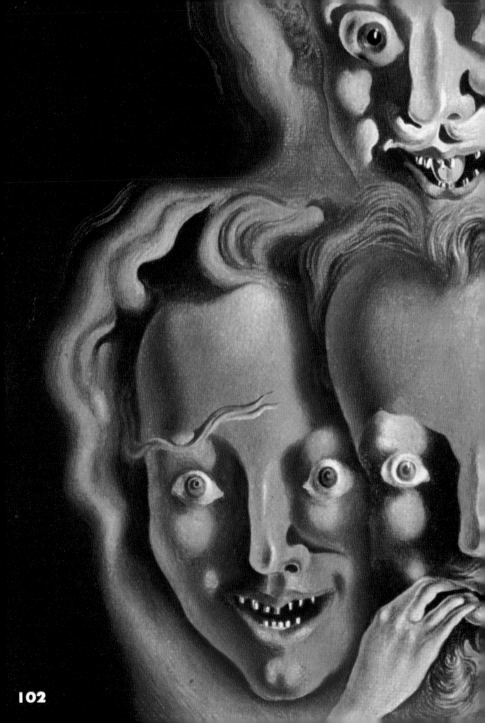

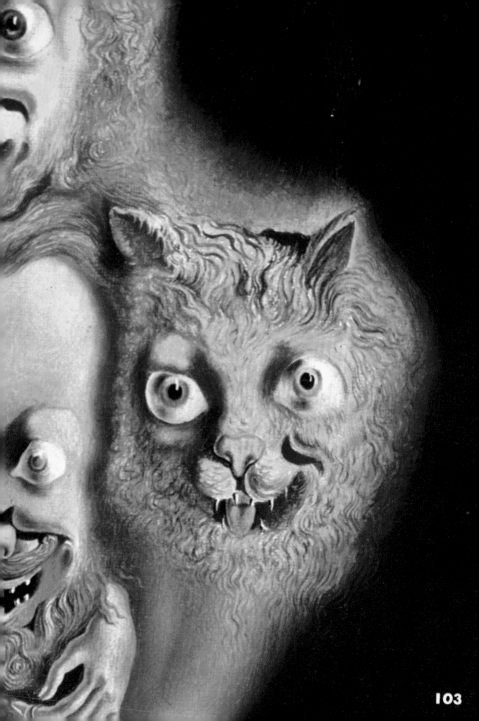

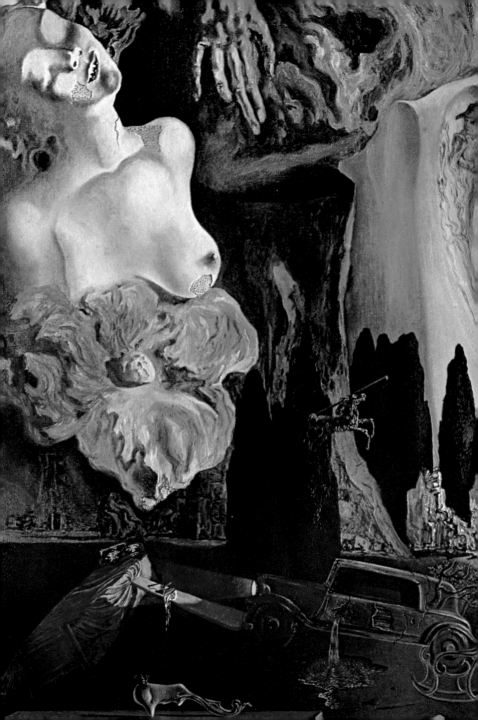

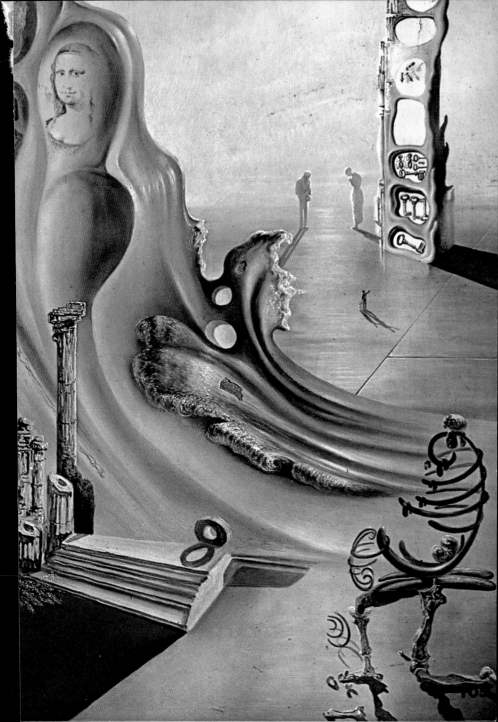

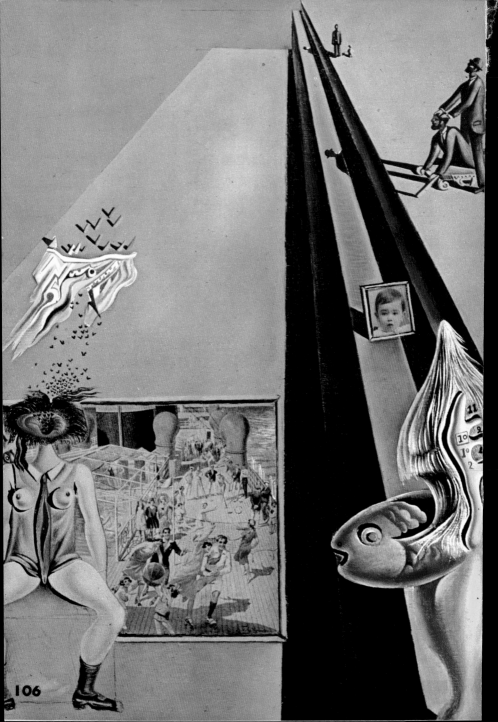

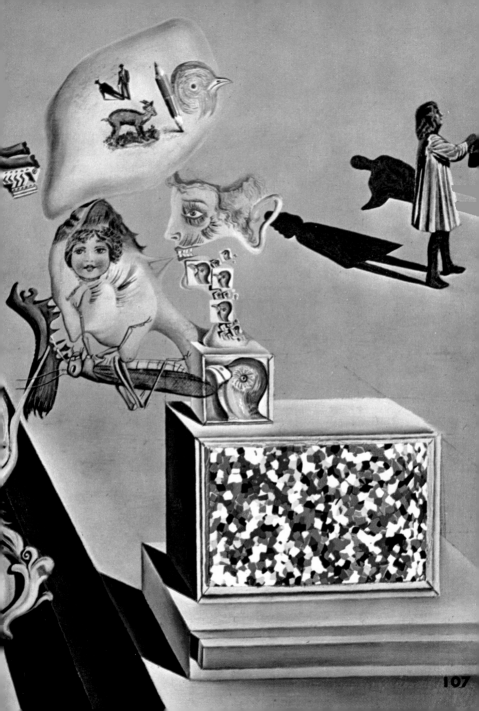

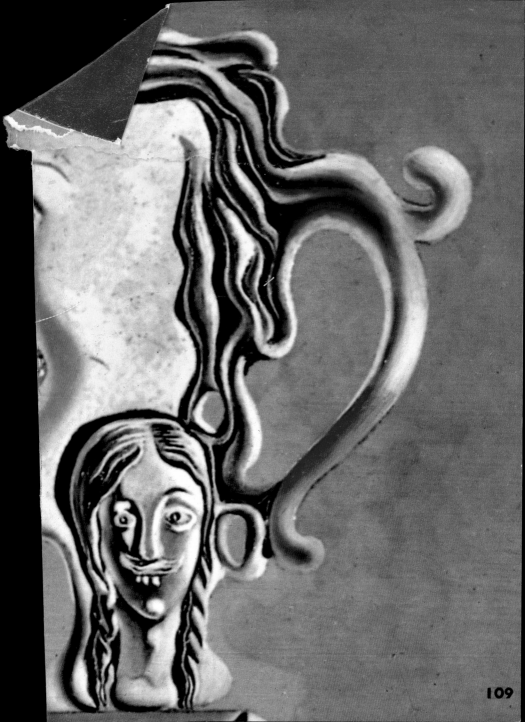

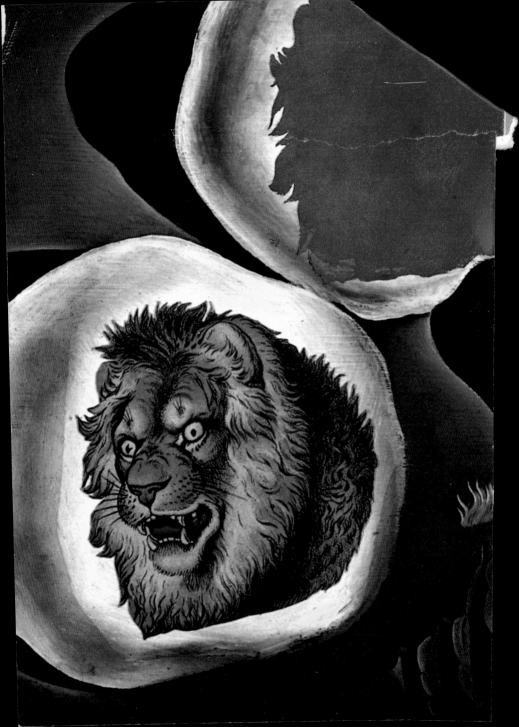

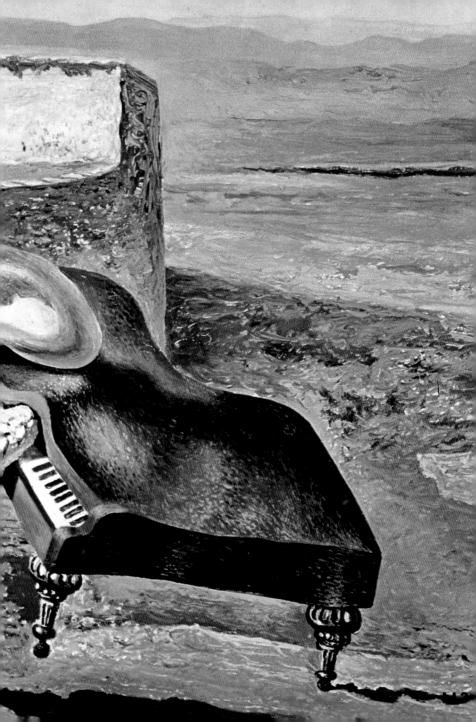

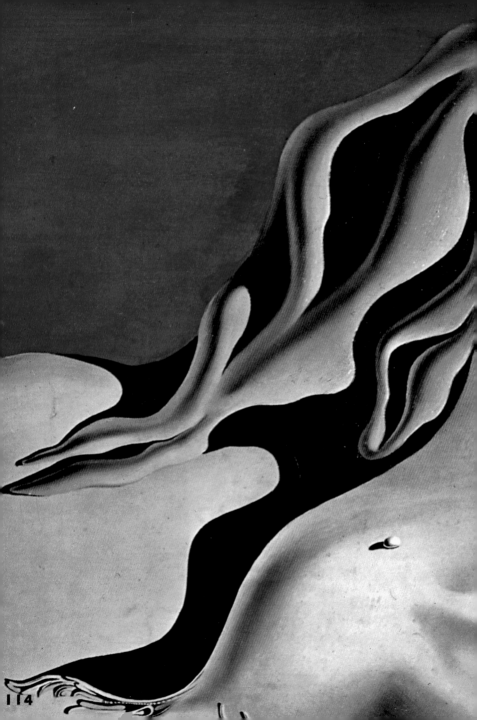

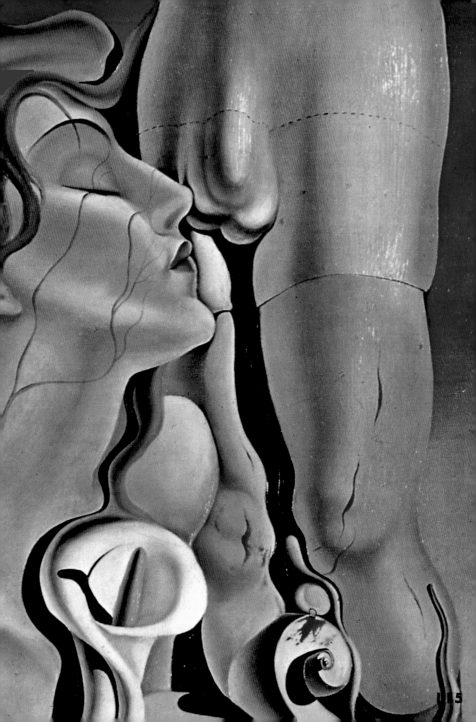

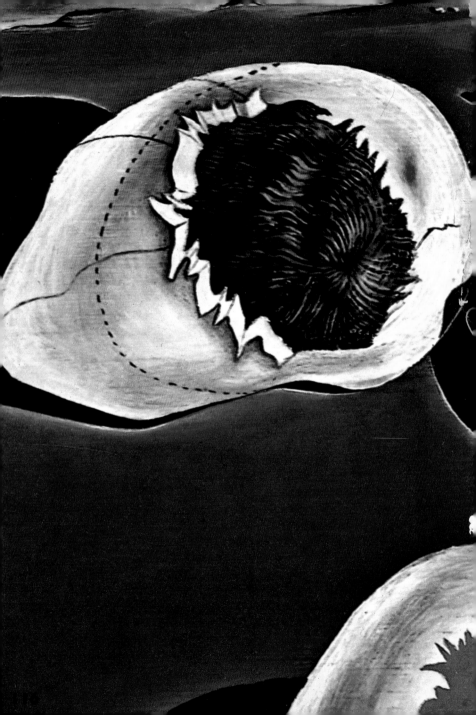

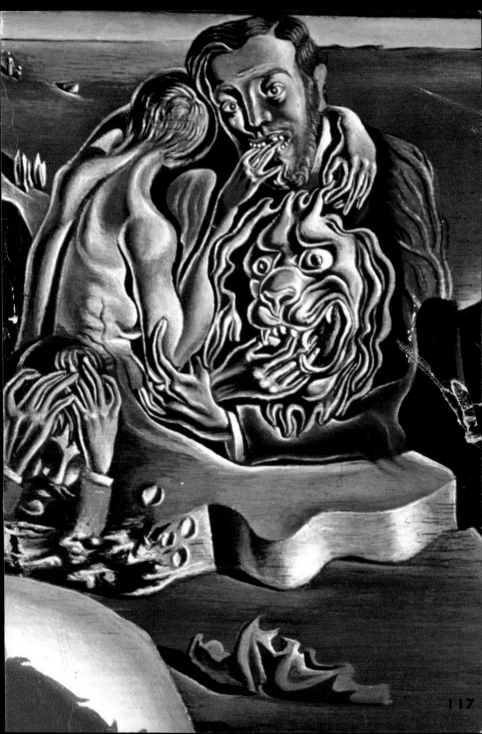

117

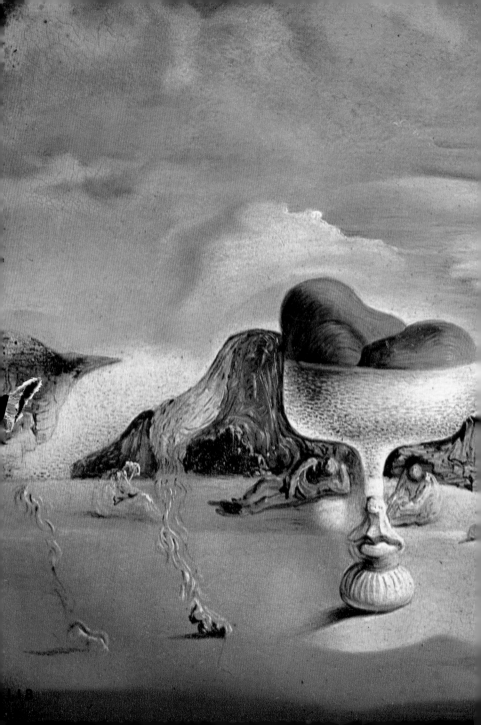

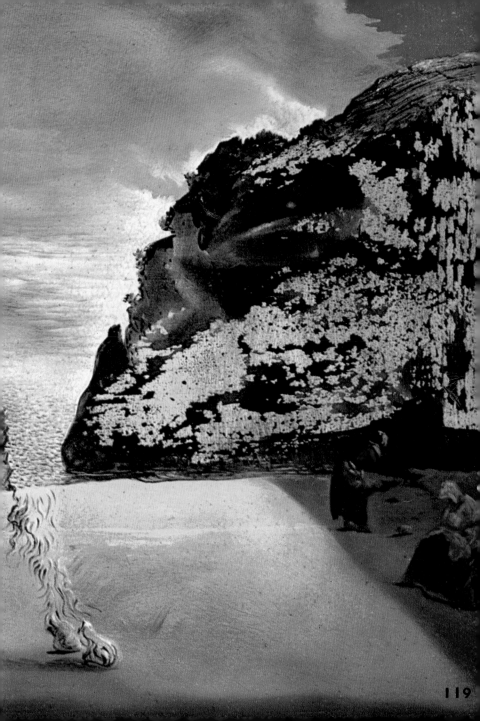

119

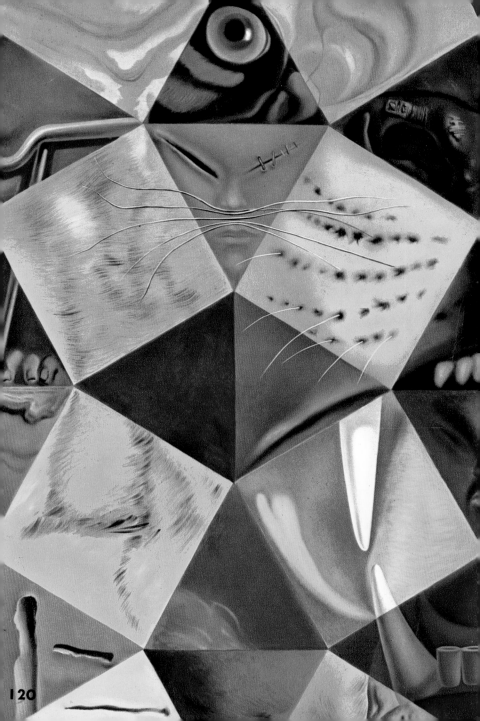

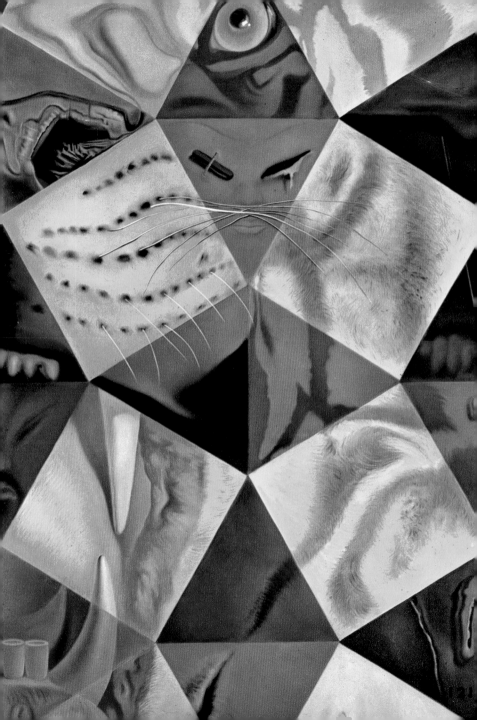

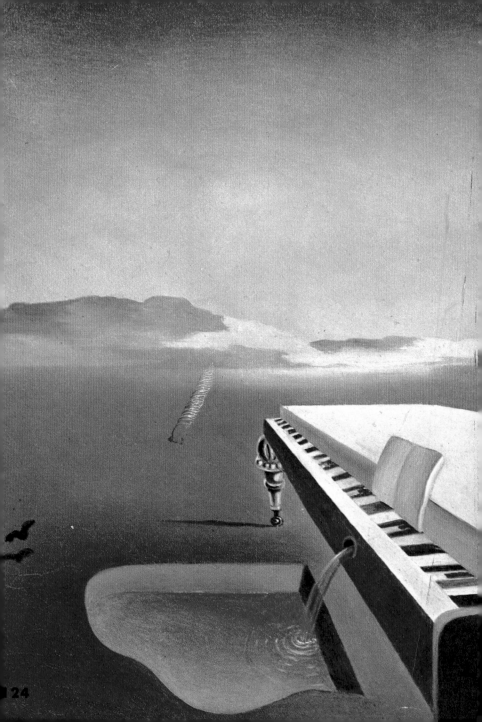

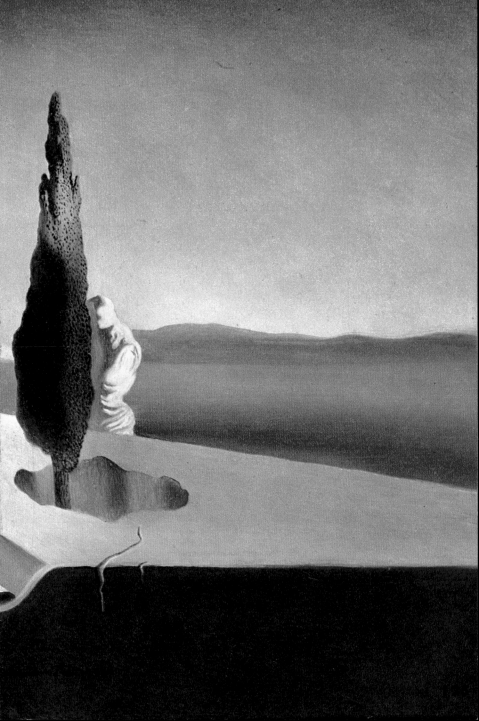

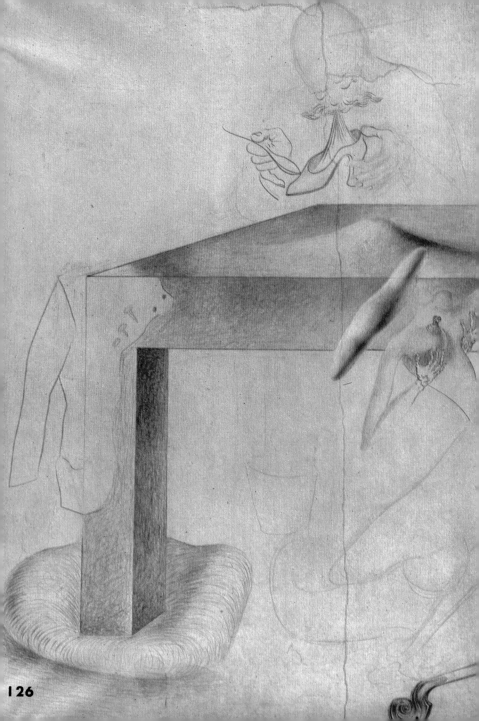

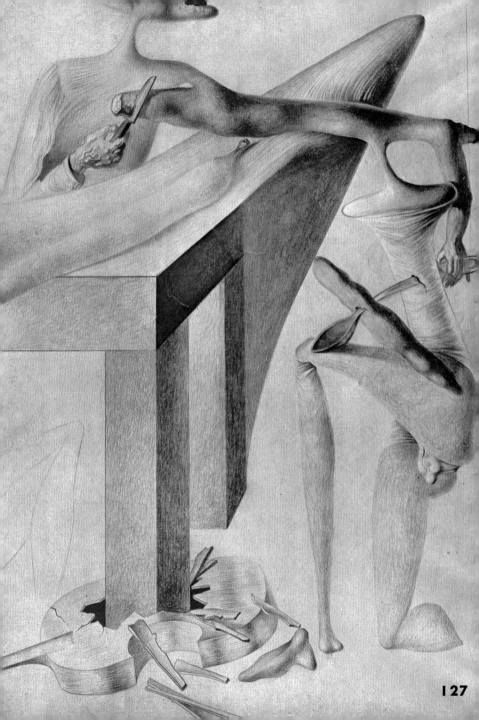

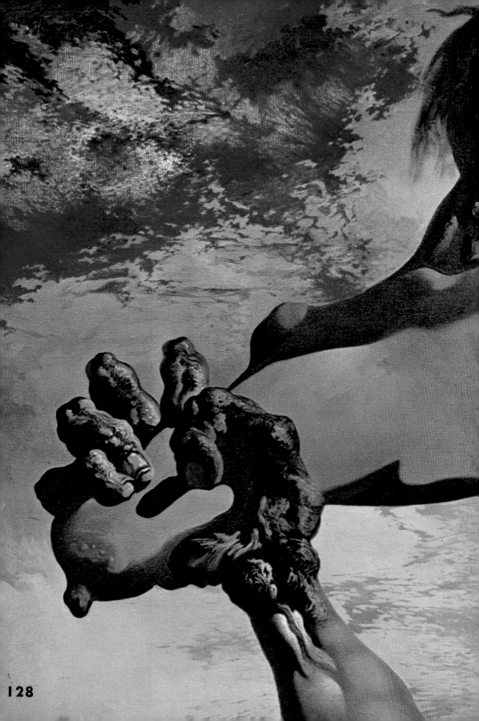

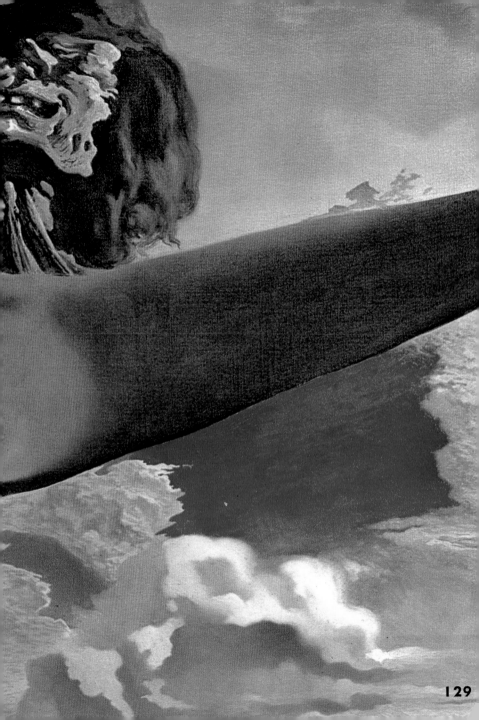

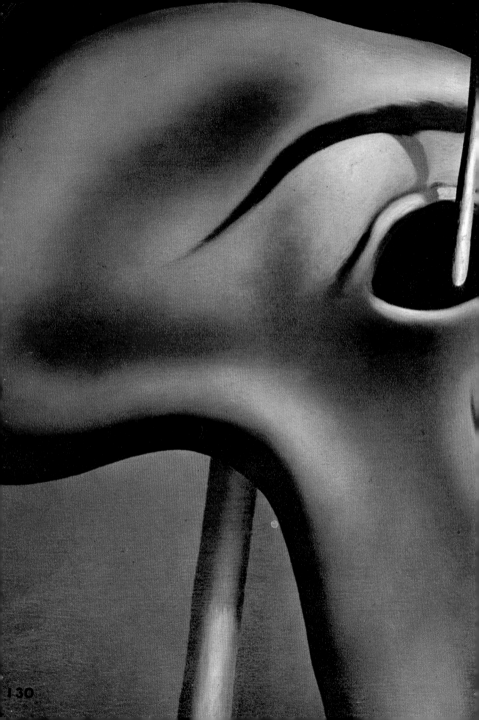

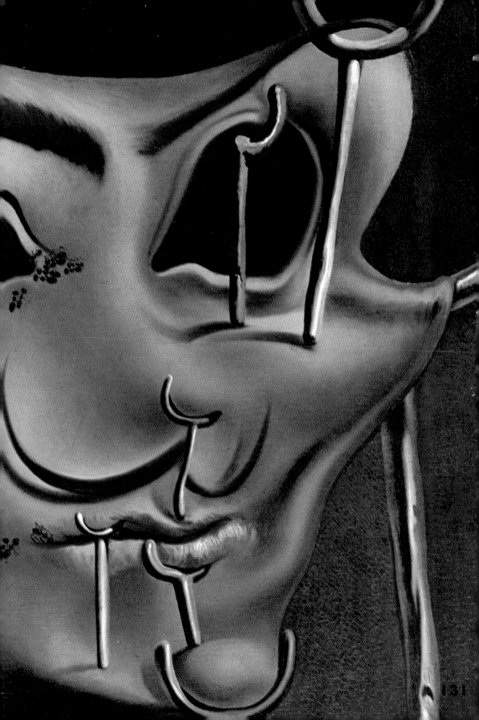

131

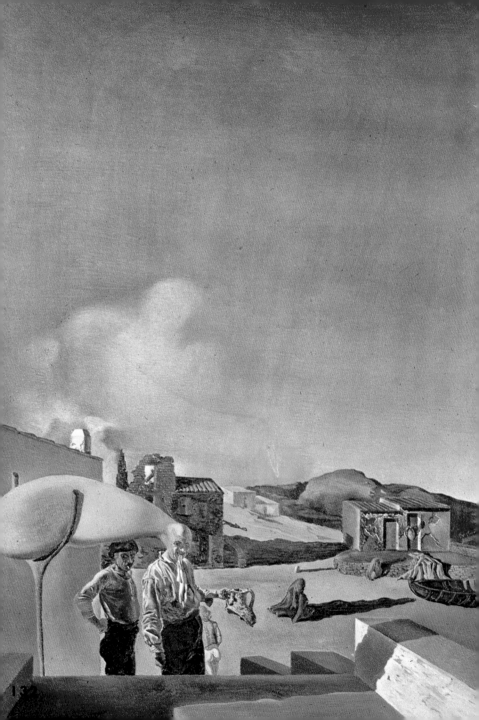

# The Futuristic Dali

pages 133 to 155

Each time someone dies, it is Jules Verne's fault. He is responsible for the desire for interplanetary voyages, good only for boy scouts or for amateur underwater fishermen. If the fabulous sums wasted on these conquests were spent on biological research, nobody on our planet would die any more. Therefore, I repeat, each time somebody dies, it is Jules Verne's fault.

But I myself, I am living, and I will live without ever liking jazz or Chinese sculpture. I have never been a pacifist. I have

never liked little children, or animals or universal suffrage, or modern art, or El Greco, or theosophy. If someone, even a handsome person, talks to me about horoscopes or asks me under what sign of the zodiac I was born, I never telephone him again. You see how miserly I am and how exceptional my intelligence must be. During the Renaissance, when they wished to imitate Immortal Greece, they produced Raphael. Ingres wished to imitate Raphael, and became Ingres. Cézanne wished to imitate Poussin, and thus became Cézanne. Dali wanted to imitate Meissonier and THE RESULT WAS DALI. Those who do not want to imitate anything, produce nothing.

Consequently, I want people to know this. From Pop and Op Art will rise Pompier Art, but a Pompier Art quantified by all that was valuable and by all the experiments, even the craziest ones, of this grandiose tragedy that we can call Modern Art.

**Dali the Futurist
is the most percussive
and the most outstanding
antiromantic, synthetic image
ever applied to the demiurgic strabismus,
Op, Pop, and Pompier Art.**

**141** - Meissonier's ultraretrograde technique is one of the most appropriate for depicting ultramodern, biological, and nuclear subjects.
He was the first painter to introduce the notion of separate particles in his handling of landscapes and genre scenes. And he was a creator of situation in space.
In the canvases of Meissonier, all the personages gaze at each other intensely. This produces the unforgettable impression of a mathematical diagram—like an unbelievable constellation —the appearance of a simple harmony between the sparkling points on the pupil of the eye, the end of the nose, a button, or the pommel of a sword, the most objectively overpolished of all painting.
We must sublimate this molecular energy of Meissonier, who used his brush to underline this or that highlight—for the emphasis he put on particles, or atoms, in a painting intensifies them with the same violence seen in the intimate visions of de Kooning.

**142-143** - To quantify in order to dynamize, in order to exalt the erotic combat, confined in a closed space (my *Tuna Fishing*), illustrating the orgiastic struggle between man and beast while adding to it intervals of acoustical holograms which express the particulate struggles near the sea.

**144-145** - To form, to re-create a third strabismal image by superimposing on the parched aridity of Port-Lligat the uterine hyperfreshness of the verdant atmosphere of the château at Pubol that I just offered to Gala, using the supercomfort of a velvety luxurious limousine and blue parrots as signposts between the mineral of Port-Lligat and the vegetable of Pubol.

**146-147** - Anxiety has driven away anguish.
The drooping figure, leaning his nose on the ground, now raises his face in sleep. In the same way, the mind dreams of conducting an orchestra of demented painters who are drawing pictorial *tramontanas* without moving a single one of the crutches that form the psychic balance of the sleeping dreamer.

**148-149** - In the future, the moment of transition will be peopled by the psychopathological and crepuscular atavism of Millet's *Angelus*, in whose drawers the greatest obsessive images of all painting lie incarnate.

**150-151** - Starting with the repeated figures of the Venus de Milo over which hover myriads of flies forming a structural unity, the first hallucinogenic, strabismic toreador is born— three-dimensional, completely hand done and in color (opus 1). It is based on *The Slave Market with the Disappearing Bust of Voltaire* by a process of psychic visual stimulation called the "Paranoiac-Critical Method."
This painting, containing all the great themes of the Dalinian works, is like the delirium of a drugless dope fiend.

**152-153** - Gala contemplating me in a state of antigravitation above my work of Pop Art, Op, yes, yes, Pompier, in which the two anguished figures of Millet's *Angelus* are seen in a state of atavistic hibernation, hypocritically pretending an imminent aggression in regard to the supremely cultivated **SUPERMAO** butterfly, bursting forth sublimely from the heart of a gigantic Maltese Cross, the center itself of the universal railway station at **PERPIGNAN** where I found, for the first time, the possibility of continuing the history of painting by superimposing the parabolic, microphysical eyes of flies which would magically give it a third dimension.

**154-155** - To clothe, to answer the prayer of the Nietzschian antigravitational superwoman, Gala, by giving her a hyper-aesthetic maximum through the dynamic multiplication of acoustical holograms resembling the angels of antimatter which carry her toward Heaven.

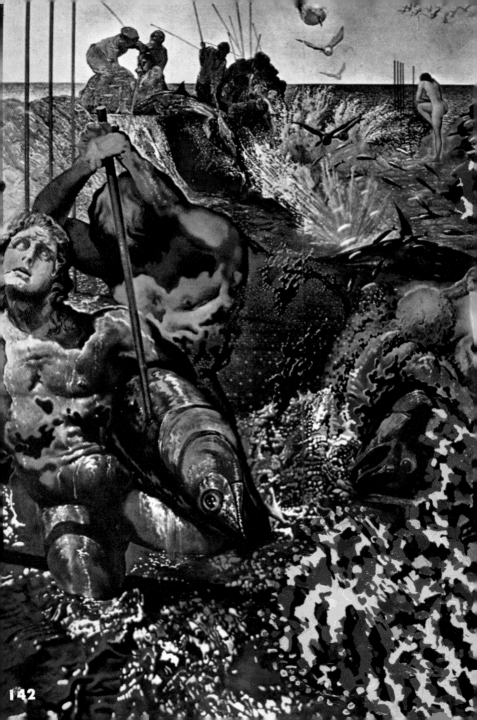

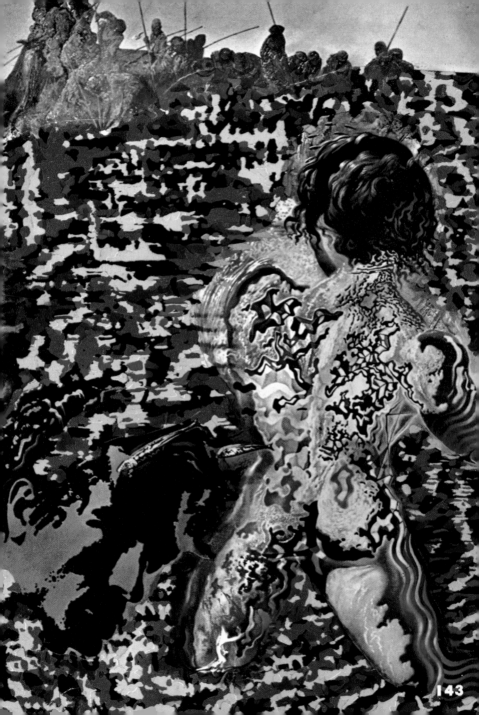

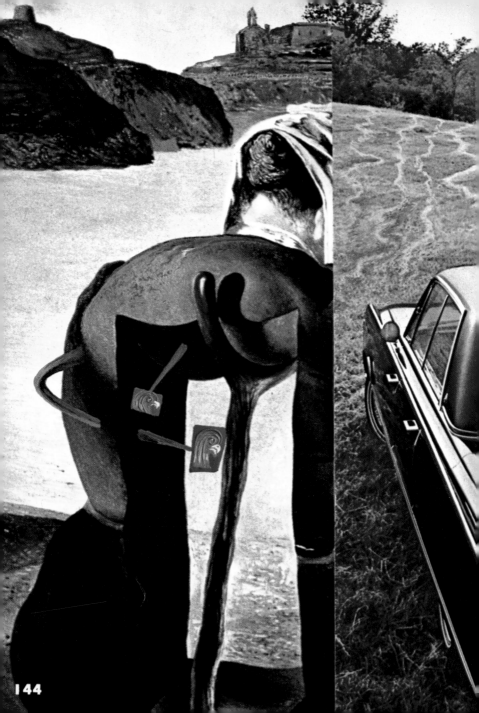

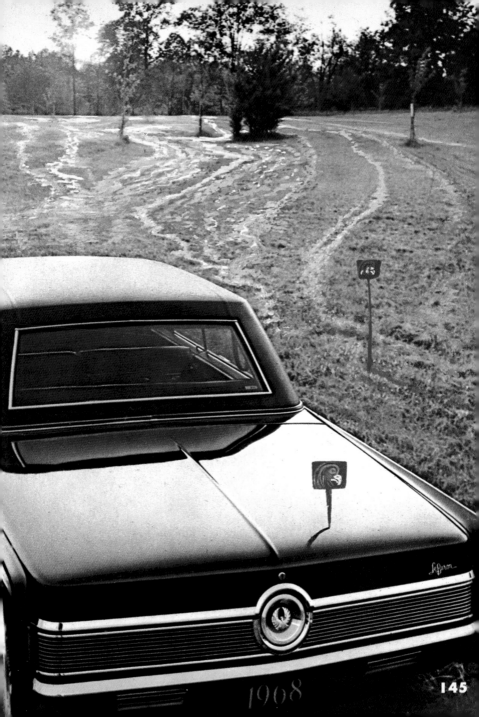

1968

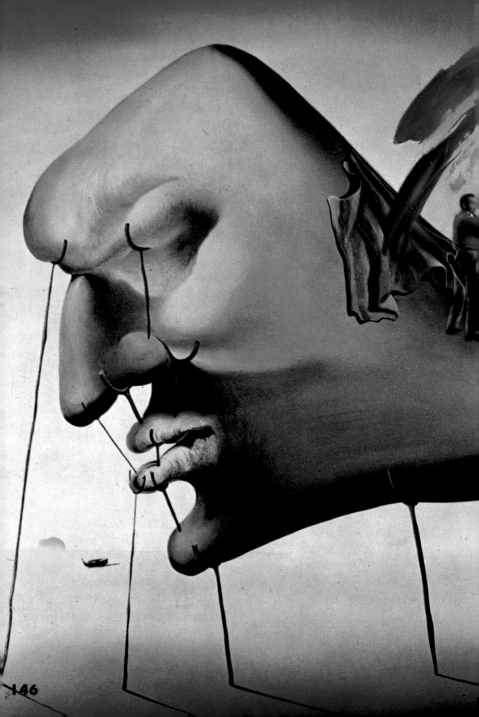

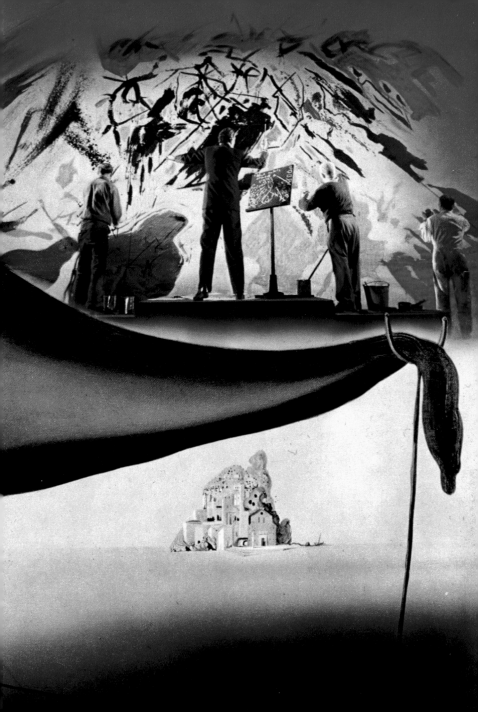

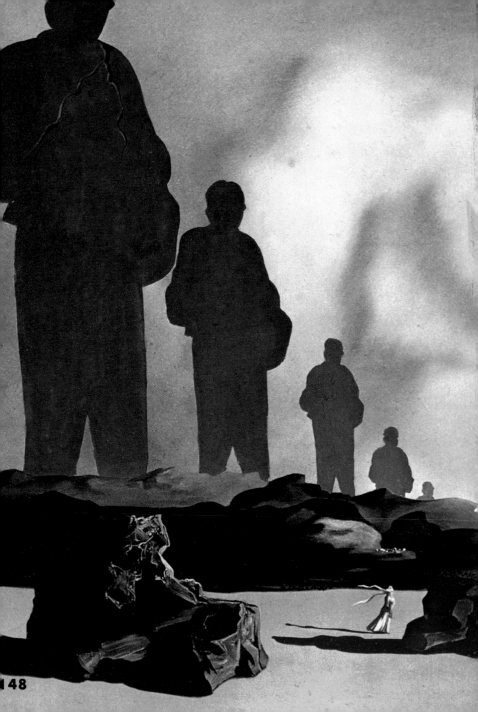

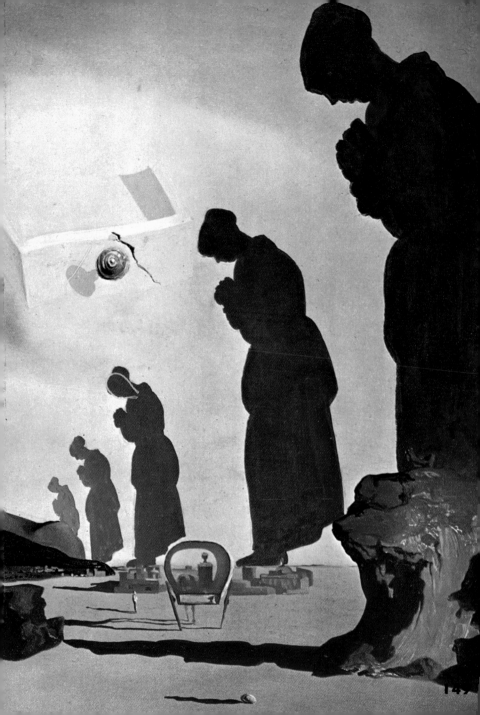

149

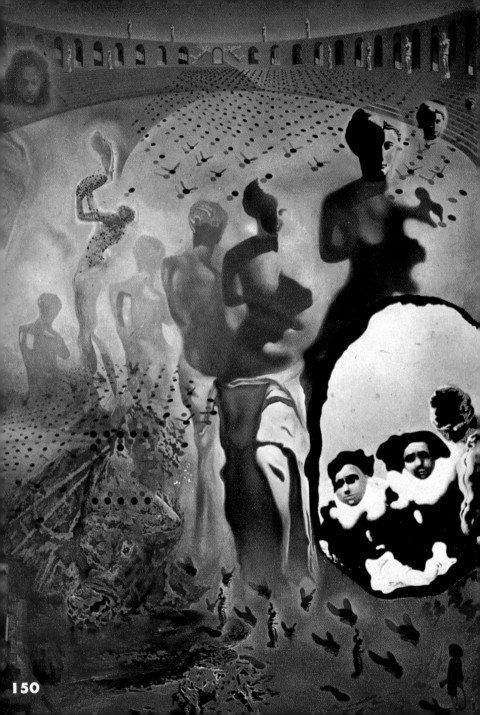

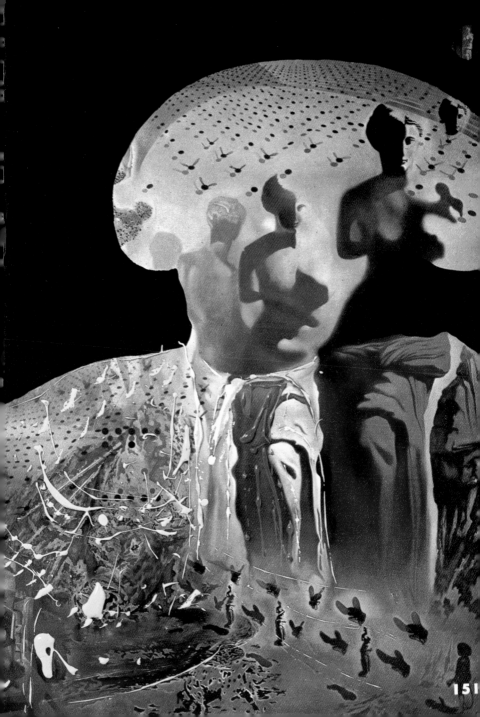

151

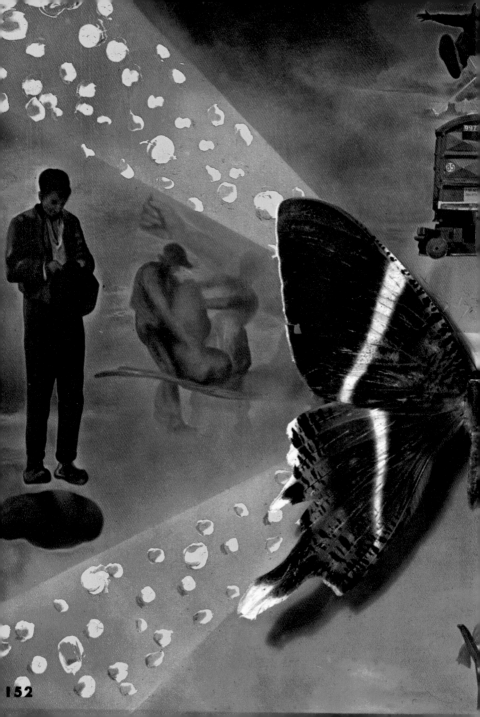

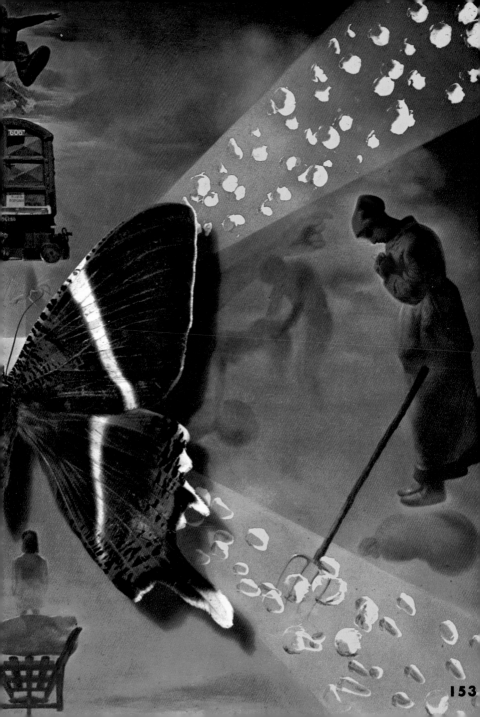

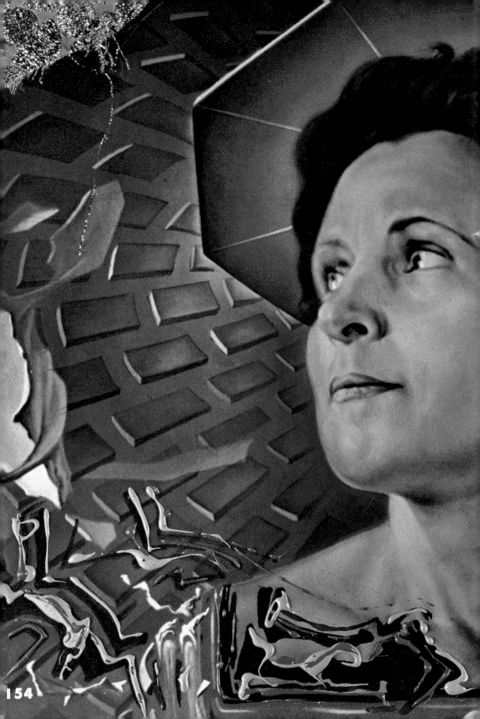